HIDDEN
HISTORY
of
ROCKY HILL

HIDDEN
HISTORY
of
ROCKY HILL

Robert Herron

THE
Hiſtory
PRESS

Published by The History Press
Charleston, SC
www.historypress.com

First published 2021

ISBN 9781467150620

Library of Congress Control Number: 2021943818

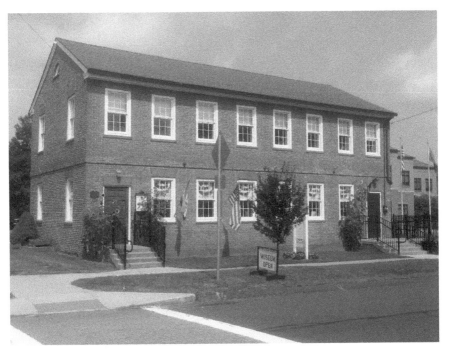

The Rocky Hill Historical Society, Rocky Hill Town Hall and the Cora J. Belden Library behind it—all rich sources of Rocky Hill's hidden history. *Author's collection.*

CONTENTS

CONTENTS

ACKNOWLEDGEMENTS

T his book began as a set of biweekly articles written during the 2020–21 COVID-19 pandemic to keep interest in Rocky Hill's history alive. Ed Chiucarello, the Rocky Hill Historical Society president, posted the articles on the Rocky Hill Historical Society's Facebook page and emailed them to the historical society's members. Mark Jahne, the editor of the local newspaper, *Rocky Hill Life*, took an interest in the articles and began publishing them in the monthly newspaper.

Many of the stories contained in this book were found hiding in the Rocky Hill Historical Society Library and the Rocky Hill town clerk's vault. Those sources provided the germ for many of these stories. In-depth detail was provided by www.ancestry.com, the *Hartford Courant* Archives, several old books on local history and the memories of some of Rocky Hill's people, including Joe Kochanek, Dr. Constantine Zariphes, Mike Martino, Martin Smith, Joan Tennyson, Peg DesRoberts, John Storm, Doug Robbins, Dave Hawkins, Fran Palazzolo, Ron Cox, Neal Cox, Ralph Hick, Beverly Tulisano, Rudy Burgess and Gladys Kitchen.

Past historians left building blocks that provided the basis for many of the stories presented here. Among these historians are Rufus Griswold, a turn-of-the-twentieth-century historian who documented much of Rocky Hill's history; Peter Revill, who played a major role in the founding of the Rocky Hill Historical Society and left several books on our history behind; and Rod Wilscam, who wrote many articles, papers and useful notes and documents.

My special thanks go to two people who have encouraged me in my writings: Ed Chiucarello of the Rocky Hill Historical Society and Mary Hogan, the librarian of the Cora J. Belden Library.

Introduction

When Joe Kochanek, who had served Rocky Hill for many years as the fire chief and mayor and who made many valuable contributions to the town's history, was in his last days, he said, "People die two deaths—first, when they die and, second, when they are forgotten." The town is making several efforts to ensure that he is never forgotten.

It occurred to me as I was assembling these stories that most of the people featured in them are almost lost to history—or at least fading from memory. The objective of presenting these stories was to find and exhibit people and their stories that are seldom visited or, in some situations, haven't been told at all. As the project progressed, I realized that an important part of my obligation as a historian is to dig deep, discover and preserve the more obscure stories of our past and preserve and report the memory of the people who built this town.

It is also worth noting that history doesn't stop at the town line. Some of these stories spill over into Wethersfield, Cromwell and Glastonbury.

ROCKY HILL'S INDIGENOUS PEOPLE

The Wangunk were the Native people who occupied Rocky Hill before the arrival of Europeans. They occupied the lands south of Hartford to the southern border of Middletown, east to the eastern border of East Haddam and west to Farmington. There doesn't seem to have been any Wangunk name for what became Rocky Hill, and there is no evidence that they had a settlement here. It is, however, likely that they hunted and fished here. They inhabited lands on both sides of the Connecticut River, and it seems likely that they used Rocky Hill as a well-suited place to cross the river.

It's a sad truth of history that when different cultures and people come into contact, conflict is more common than cordiality. This was true of when the Mohawks, members of the Iroquois League, moved south from the area around Albany, New York, and invaded the Connecticut River Valley. The people of the valley, including the Wangunk, were Algonquin people who spoke a different language and had different customs. The Mohawk were a warlike people, whereas the people of the Connecticut River Valley were comparatively peaceful. The Wangunk made an attempt to fend off the Mohawk, but ultimately, the Mohawk prevailed. A group of Mohawk were set up in a permanent stockade in South Glastonbury and began exacting tribute from the Wangunk.

A plague (possibly smallpox or measles brought by European traders and fishermen) hit the people of southern New England in 1616 and 1617,

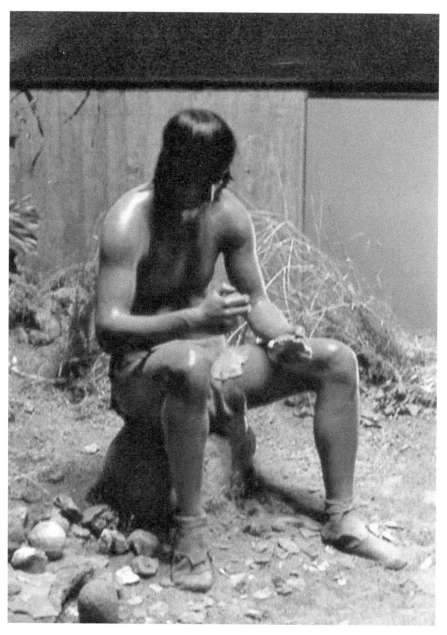

Pre-Columbian inhabitant. *Courtesy of the Rocky Hill Historical Society.*

killing up to 90 percent of the population. The Mohawk weren't affected by this plague and were able to bring large numbers of warriors to bear on the depleted Connecticut population.

Paying tribute to the Mohawk was an unpleasant but bearable burden. Things got worse when the Pequot, another group of warlike people, began coming up the Connecticut River. They, too, exacted tribute from the Wangunk.

Sowheag, the sachem of the Wangunk, sent one of his sons to Watertown, Massachusetts, to urge English colonists to settle in his lands. He had heard of the Europeans' fierceness and the power of the firearms and edge weapons that gave them an advantage in war. He hoped to form an alliance. In 1634, John Oldham led a group of settlers to Wethersfield. The Mohawk assessed the situation, decided that discretion was the better part of valor and left. The Pequot weren't so easily intimidated.

As part of his deal with John Oldham, Sowheag stipulated that he might "sit down by them and be protected," meaning he could reside in Wethersfield and find common cause against the Pequot. It seems difficulties arose between the colonists and Sowheag almost immediately—partially because the Wangunk realized they were being marginalized and forced off their land. The Wangunk removed themselves to Mattabesick (Middletown).

On July 20, 1636, while John Oldham's ship was anchored at Block Island, it was boarded by Natives. He and five of his crew were killed, and his two young nephews were captured. His nephews were later rescued. Then politics entered the picture. The Pequot had been attacking colonists on the Connecticut River, and some of the colonists had been killed. Massachusetts Bay Colony leaders, who had reasons to want to avoid war with the Narragansett, blamed the Pequot for Oldham's killing and ordered attacks on them.

In 1637, the Pequot launched a surprise raid on Wethersfield. Nine settlers, six men and three women, were killed, and two young girls were taken captive. In addition, twenty cattle were killed. The captive girls were soon rescued by Dutch traders for a ransom and returned to their parents. Retaliation for this raid resulted in the infamous attack by English settlers on Fort Mystic in Groton, the Pequot's home. The Mystic Massacre took place on May 26, 1637. Connecticut colonists under Captain John Mason and their Narragansett and Mohegan allies set fire to the Pequot Fort near the Mystic River. There were two gates, and they shot anyone who tried to escape the wooden palisade through these bottlenecks. Estimates of Pequot

deaths range from four hundred to seven hundred, and they included mostly women, children and the elderly. Most of the Pequot warriors, who were away from the fort, escaped north, where they were massacred by the Mohawk. The Pequot numbers were so diminished that they ceased to be a tribe. Many of the remaining Pequot in Connecticut were killed or sold into slavery, some being sent to the Caribbean Islands. The Narragansett and Mohegan were so appalled by the brutality of these actions that their relations with the colonists changed dramatically. European settlers suspected that Sowheag had encouraged the attack on Wethersfield, and the relations between colonists and the Wangunk never recovered.

As the colonists gained power, their relations with the Native people deteriorated. By the time the Wangunk could react, the colonists had gained control of vast expanses of land and were farming them. Moreover, the colonists increasingly treated the Natives with contempt, questioning things like their morals, honesty, hygiene and intelligence. Words like *savage*, *heathen* and *aborigine* were not uncommon in colonial writings.

Instances of colonists building on and cultivating Wangunk land without permission became common. They no longer negotiated land sales with the Wangunk; rather, they brought their petitions for land to the Connecticut General Assembly, with predictable results. The ownership and population of ancestral lands by the Wangunk dwindled. The experience of Native people throughout New England followed this pattern.

Things came to a head in eastern Massachusetts when the colonists asserted legal authority over the Wampanoag and executed several of them, including Metacomet's (also known as King Philip's) brother. A bloody war ensued, which spread throughout New England from 1675 to 1678. One in ten soldiers on both sides was killed, often brutally; 1,200 colonists' homes were burned, and vast stores of foodstuffs were destroyed. More than half of all New England towns were attacked by Native warriors, including towns as close to Rocky Hill as Simsbury, although Rocky Hill seems to have been spared. Many towns were completely destroyed. At the end of the war, many of the Native people were enslaved and transported to the Caribbean Islands.

The Wangunk did not seem to have had any involvement in King Phillip's War, but the hostility the colonists felt toward the Native people seemed to encompass them. Moreover, the colonists had taken over the territory, marginalizing the Wangunk and restricting them to less and less land. Some were absorbed into neighboring tribes, such as the Tunxi and Mohegan. By 1774, there were twenty-eight Wangunk left living in

Chatham (modern-day Portland), the final refuge of the Wangunk. Many of the Wangunk migrated from New England to Iroquois lands in Oneida County, New York. After the Revolutionary War, these lands were given to war veterans. In the 1830s, the Wangunk were moved to Wisconsin, where they were absorbed into the population.

ABIGAIL (SMITH) GRIMES,
A FOUNDING MOTHER OF ROCKY HILL

In the middle of the seventeenth century, the town of Wethersfield issued grants for four riverfront properties: The Boardman Grant, the Williams Grant, the Shipyard Grant and the Smith Grant. Joseph Smith died in 1673, leaving his grant to his wife, Lydia (Wright) Smith. She willed the grant to her son Jonathan. Jonathan Smith seemed to acquire the northern two-thirds of the Boardman Grant before his death. He willed the land in equal shares to his children: Nathan, Abigail and Hannah. When Nathan died in 1733, he willed his estate in equal shares to his sisters. Hannah married Daniel Clark of Middletown, and Abigail married Hezekiah Grimes. Hezekiah acquired Hannah's share in 1742, so the Smith-Grimes family ended up owning the land between the northern two-thirds of the foundry property and the Meadows.

Society and legal rights in New England were highly patriarchal in the seventeenth and eighteenth centuries. It shouldn't be inferred from this that the women of the Smith-Grimes family were passive tools of their husbands. Although some surviving documents give the impression that Hezekiah Grimes controlled family affairs, he died in 1749, and his wife, Abigail, clearly served as a strong matriarch until she died in 1792.

By the end of the Revolutionary War, Rocky Hill had become an active river port. What had once been an undeveloped wilderness in the 1660s had become a booming port, a shipbuilding center and a valuable stretch of property. When the grants for the riverfront properties were drafted, the wording was vague as to the rights and boundaries of the grants. The

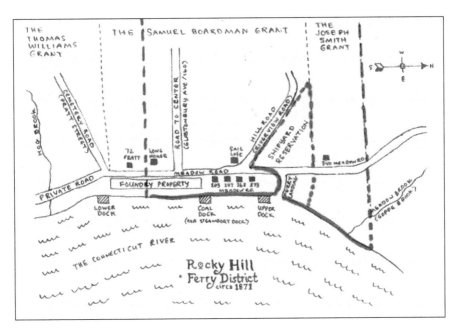

Original grants. *Author's collection.*

original grant had called for a fence with a gate to be built between the Smith Grant and town property. The exact boundaries between the two properties were not well defined.

The Town of Wethersfield attempted to capitalize on this vagueness, starting in 1786. Stephen Mix Mitchell and John Chester, prominent Revolutionary War officers and public figures from Wethersfield, and Esquire John Robbins, who owned Broadview Farm in Rocky Hill, were appointed a committee of agents for the town to purchase the "pretended right to the shipyard and some part of the town's land adjoining the five acres which constituted the shipyard." The town's use of the word *pretended* hints at its position. Abigail put up a protracted fight and was able to keep most of her property, although Wethersfield gained undisputed ownership of the shipyard and the adjoining landing.

During the period of over forty years that Abigail Smith, the widow of Hezekiah Grimes, survived him, the Smith Grant and the ferry privilege remained in the family. She died at the age of eighty-eight, having successfully held most of the land from the grants and the ferry privilege together for her family.

THE BIRTH OF THE FERRY

T he Rocky Hill–Glastonbury ferry was closed for much of 2020 because of the COVID-19 pandemic. It reopened on June 20, 2020, with precautions in place, preserving its status as the oldest ferry in North America in continuous operation.

How old is the ferry? The most popular start dates seem to be 1650 and 1655, although no reliable source has been found to prove or refute these dates. But this asks some challenging questions about the ferry's origins and, hopefully, moves us toward answers.

We know that farmers were crossing the river by 1636 to get to their fields in South Glastonbury. They must have had some way to cross the river, but it is hard to tell when ferrying became an orderly commercial enterprise.

This entry was recorded in the Wethersfield Town Votes Book, Vol. 1, in 1649:

> *This second of Jana* [sic]*: 1649....At this meeting, the town voted, and by their vote, granted that there should be a higt way, for use of the towne, at the foot of Rockki Hill* [present-day Rocky Hill]*, near beauer brooke* [present-day Goffe Brook]*, to run southward from that way which comes out of Beauer medow. Unto the great reuer* [the Connecticut River]*, in the most convenient place, and to the end of the hill into the common* [Glastonbury Avenue]*; for use of the towne, and a hight way to Nayog farmes* [present-day South Glastonbury].

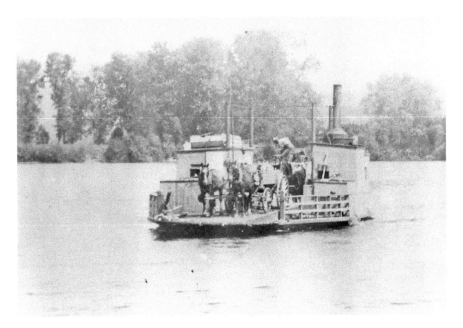

Steam ferry, Rocky Hill. *Courtesy of the Rocky Hill Historical Society.*

So, a highway was authorized from the center of Rocky Hill, down Glastonbury Avenue and across the river to South Glastonbury. Some things should be noted. First, the highway had to cross the river to get to Nayaug Farms (South Glastonbury), so the ferry was part of the highway. Second, since the general assembly had jurisdiction over the highways (a highway was any major road at the time), Connecticut Colony had jurisdiction over the ferry.

In 1673, the general assembly granted Jonathan Smith "the liberty" of the ferry (what was meant by *liberty* is unclear, and it would result in some complex court cases at the end of the nineteenth century). Jonathan's descendants operated the ferry until 1860.

The Smith-Grimes family lived at what was 205 Meadow Road for many years (this building was torn down in 1953). Land records show that there was a path twenty-five feet wide abutting the northern edge of their property that ran from Meadow Road to the river. These records say that it was intended "for use of the ferry." By then, the access road was being called a "gangway" that lead to a dock called the Steamboat Dock (it later became the Coal Dock and was used by the foundry to unload coal). If this was the original ferry landing, it had moved to its present location by 1844.

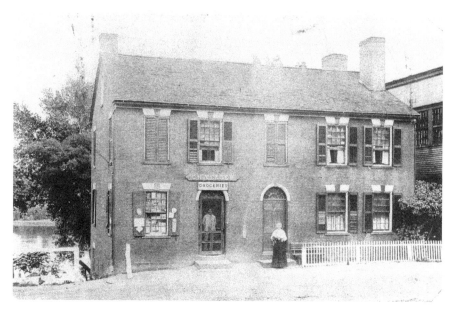

205 Meadow Road. *Courtesy of the Rocky Hill Historical Society.*

Looking toward the landing from Shipyard Park. *Courtesy of the Rocky Hill Historical Society.*

Did this twenty-five-foot-wide access path lead to the original ferry landing? This makes sense. It abuts the ferry operator's home, and it's almost a straight shot from Glastonbury Avenue (the highway). In old documents, the place where the modern ferry landing is located was simply called "the Landing." It was the location of a booming shipyard, often building six to eight ships at any time and sliding them down the hill to the landing to launch. There were also ships coming and going from the Upper Dock near the landing. Would you want to try to land a slow-moving, pole-driven ferry barge at this busy place?

If you want to play history detective, there might be a fun field trip here. Let your imagination take you back in time. Shipyard Park on Riverview Road is located where the shipyard once was. Sadly, the view of the river is now obscured by trees. Across Meadow Road from the old railroad station, there is a foundation of an old building and a path that abuts it on the north that runs to the river. There's a construction trailer there today. This may not be the original foundation of the Grimes house, as the foundry later had a metal treating facility on this site, but this is the original location of the Grimeses' home.

SLAVERY IN ROCKY HILL

There were no *Gone with the Wind*-style slavery-based plantations in Rocky Hill, no slave markets on the landing or at the Duke of Cumberland Inn, no slaves being driven through the meadows in chains. Several *Hartford Courant* articles in the 1980s made these claims, but they seem to have been written to stir people's blood and enlist support in opposition to the construction of condominiums in the quarry by creating a false history of the area. The ploy worked; the condos weren't built (thank goodness), but the real history of slavery in Rocky Hill has been obscured by these stories. That is not to say there wasn't slavery in Rocky Hill—there was, and it was just as wrong as the southern model.

Some context is needed to understand the history of slavery in Rocky Hill. *The Negro in Colonial New England*, by Lorenzo Johnston Greene; "Slavery in Connecticut," a study done by Yale University; and *Slavery in Connecticut*, from Princeton University, all studied this issue and came to the same conclusions.

The two main reasons slavery never became as widespread in New England as it did in the South were weather and religion. The growing season is very short in New England. A way had to be found to feed, shelter and clothe an enslaved work force in the winter. Some enslaved people were taught skills, like carpentry or blacksmithing, but the White tradesmen and their guilds resisted this. Some African Americans went to sea as sailors; many performed unskilled labor; and many could be found working on the docks. Black slaves were often referred to as servants, and owning a so-called servant seems to have been more a status symbol than a profit-making venture.

Slave chains. *Author's collection.*

The Congregational church was the official state church of Connecticut until 1818. There was once a slave galley in the Rocky Hill Congregational Church that accommodated about twenty people. Enslaved people were considered improvable individuals with souls at this time—*improvable* meaning capable of adopting the cultural, educational and religious beliefs of White people. Given that church attendance was compulsory for everyone at the time, attendance at church by the enslaved was probably also compulsory.

In 1730, there were about sixteen slaves in Rocky Hill out of a population of approximately eight hundred people. All of the slaves who have been discovered to date were owned by wealthy people in the maritime trades. For example, a wealthy shipowner had four of his enslaved people aboard his ship when he returned from the South. Esquire John Robbins, who owned the Duke of Cumberland Inn on Old Main Street, owned as many as seven enslaved people. Dr. Constantine Zariphes, who owns the Duke of Cumberland Inn today, tells of finding a set of shackles embedded in the floor of the inn. He had them removed to avoid upsetting his grandchildren.

Maritime New England, including Rocky Hill, profited from the slave trade, either directly through its involvement in the triangular slave trade, or indirectly through conducting the trade necessary to support slavery in southern colonies and the Caribbean Islands. There were slave markets in Boston and the Rhode Island ports; in fact, Brown University in Providence was endowed with proceeds from the slave trade. Attempts were made to establish slave-based plantations in Rhode Island and eastern Connecticut. Middletown, which was the fourth largest port in New England at one time, had people who owned large numbers of enslaved people. Two attempts were made to import enslaved people and establish a slave market, although they seem to have failed. Aside from these few slave markets, slaves were bought and sold through newspaper advertisements, handbills and word-of-mouth exchanges.

Men were masters of their households in colonial times, with the right to beat their wives, children and enslaved people. There is an impression that the enslaved were always treated well—often like members of the family—in Rocky Hill. While this may have been true in some cases, it was clearly not always true. There are several accounts of enslaved people committing suicide. The legislature had to pass a law requiring slave owners to be

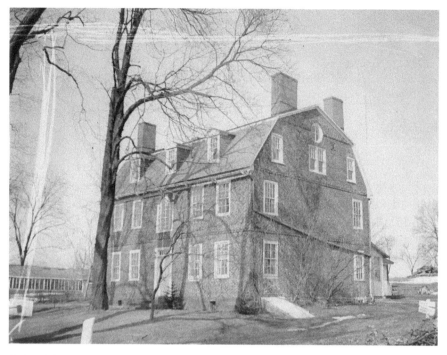

Duke of Cumberland Inn. *Courtesy of the Rocky Hill Historical Society.*

responsible for the enslaved throughout their lives, as it was not uncommon for a slaveholder to free an enslaved person when they were too old to work, disabled or in some other way unproductive. This, in effect, put helpless people out on the street to fend for themselves.

Over time, the responsibilities of slave ownership began to outweigh any benefits. The general assembly passed a bill in 1774 outlawing the importation of enslaved people into Connecticut. This meant that any future population of enslaved people would have to be drawn from the children of the existing enslaved. In 1784, the general assembly passed the first Gradual Emancipation Act, which provided that anyone born into slavery after that time would be freed on their twenty-fifth birthday. A second Gradual Emancipation Act was passed in 1797 and lowered the emancipation age to twenty-one. This meant that slaveholders were responsible for raising these children to adulthood, at which time, the enslaved would become free. Slavery was outlawed altogether in Connecticut in 1848, although, by that time, there were only six enslaved people left in the entire state.

The following passage can be found on page 945 in *History of Ancient Wethersfield* (1904):

> *Narragansett Bay was the home of many vessels surreptitiously engaged in transporting Blacks from Africa. Whether or not the same sort of trade was carried on the from the wharves of Rocky Hill cannot be known: the probabilities are that some of it was done, for the people here were not less enterprising than other New Englanders, and quite as ready to make an honest dollar.*

Enterprising? An honest dollar? Racism was clearly alive and well when this was written in 1904. The same words were repeated, verbatim, on page 90 of *Wethersfield and Her Daughters* in 1934. No reliable evidence has been uncovered that any Rocky Hill ship ever served as a slaver.

ROCKY HILL IN
THE REVOLUTIONARY WAR

Rocky Hill was located on the Lower Post Road, and travelers provided ready access to information on the issues of the day. Traffic on the Lower Post Road and across the Connecticut River on the ferry carried news of dissention against the British to Rocky Hill. There were discussions among the colonists as to the amount and fairness of the English taxes and the lack of colonial representation in the English Parliament. The *Hartford Courant*, the oldest newspaper in continuous publication in the United States, was founded in 1764 as the *Connecticut Courant*. During the Revolutionary War, the *Courant* had the largest circulation of any newspaper in the colonies and was an influential backer of the rebel cause. It was certainly widely read in Rocky Hill.

Trade with southern and Caribbean English colonies was an essential part of Rocky Hill's economy during the colonial period, and English taxes were an accepted fact of life. But at the end of the French and Indian War, taxes increased substantially, placing a heavy burden on Rocky Hill. With no representation in parliament, Rocky Hillians sensed that they were being treated as second-class citizens. This added fuel to the fire.

In 1774, the Connecticut General Assembly appointed Silas Deane of Wethersfield, Eliphat Dyer of Windham and Roger Sherman of New Haven as delegates to the Continental Congress to address tensions with the mother country. The train band in Wethersfield, a militia unit that had been in existence since King Philip's War, was readied for war under the command of Colonel John Chester. Barnabas Deane, Silas Deane's brother,

A sign from the Duke of Cumberland Inn. *Courtesy of the Rocky Hill Historical Society.*

influenced him to lobby for the authorization of a Connecticut navy and privateers. Notable among these ships was the *Brig Minerva*, built by William Griswold in Rocky Hill. Another was Barnabas Deane's brig, the *Revenge*, which, although it wasn't built in Rocky Hill, probably operated from here. The *Revenge* was one of the many ships lost at the Battle of Penobscot Bay in Maine in 1779, the worst United States naval disaster until the attack on Pearl Harbor.

The "Lexington Alarm" occurred as a response to the Battles of Lexington and Concord, when men marched to protect Boston from the British. As soon as word of this was received in Wethersfield, troops mustered. When the events that led up to the Revolutionary War occurred, the residents of Rocky Hill were still citizens of Wethersfield, so Rocky Hill men served in the Wethersfield militia. There is a story of a group of men who were marching to the muster in Wethersfield from Rocky Hill and passed the Duke of Cumberland Inn (now 262 Old Main Street). At that time, the inn's sign was a picture of the Duke of Cumberland, King George II's son. In a frenzy of patriotism, the marchers riddled the sign with musket balls. Today, the sign hangs at the Connecticut Historical Society in Hartford.

The Sixth Connecticut Regiment was raised on May 1, 1775, in New Haven, Connecticut, as a provincial regiment of the Continental army. It became a regiment of the Continental line on January 1, 1776, designated the Tenth Continental Regiment, and a regiment of the Connecticut line on January 1, 1777, again designated the Sixth Connecticut. The regiment saw action at the Siege of Boston, the Battle of Long Island and the New York Campaign and served in the Corps of Light Infantry at the Battle of Stony Point. The regiment was merged into the First Connecticut Regiment on January 1, 1783, at West Point, New York, and disbanded on November 16, 1783.

Across the thirteen colonies, not all colonists supported the rebellion. Historians guess that perhaps one-third of the population supported it, one-third were Tories who opposed it and one-third were ambivalent.

Connecticut was firmly on the side of the rebellion, as were most Rocky Hillians. Connecticut became known as the Provision State because it supplied a large share of the men, supplies, food and equipment for the revolutionary cause.

Some of the military volunteers from Rocky Hill included: John Atwood*; Elisha Belden*; Elijah Boardman*; Edward Bulkeley; Joseph Bulkeley; Roger Bull*; Thomas Bunce*; Reverend Calvin Chapin; Gideon Cole; Caesar Freeman**; Jacob Gibbs; Jonas Clark Gibbs; Gideon Goff Sr.; David Goodrich; Elizur Goodrich; Hosea Goodrich; Ichabod Goodrich; Isaac Goodrich; Jacob Goodrich; Jared Goodrich; Ozias Goodrich*; First Lieutenant Stephen Goodrich*; Captain William Goodrich; Constant Griswold*; Aaron Horsford*; Thomas Holmes; Moses Kelsey*; William Kelsey*; John Miller; Benjamin Morton*; Lieutenant Oliver Pomroy; Jacob Rash*; Aukley Riley*; Ashbel Riley; Roger Ripner; Frederick Robbins; John Robbins; Colonel Josiah Robbins; Asher Russel; Nathaniel Russell*; Thomas Russell; David Smith; Gershom Smith*; James Stanley; Ensign William Warner*; Elias Williams; Israel Williams; William Williams; Ashbel Wright*; and possibly others. These names are from the list of Wethersfield veterans of the Revolutionary War, compiled by Rod Wilscam in 2002 and supplemented by recent documentation of Rocky Hill Center Cemetery. Those names with asterisks (*) were among the volunteers who attended the Lexington Alarm. The double-asterisk (**) is Caesar Freeman, an enslaved person who was manumitted to serve in the Continental army. This is probably not an exhaustive list and will be added to as we learn more. There are also many more detailed stories of Rocky Hill in the Revolution yet to be told.

THE REVOLUTIONARY *MINERVA*

T he ship depicted in the image that accompanies this chapter isn't the *Minerva*, but it is a brig much like the *Minerva*. Note that it has a weather gauge (it's upwind), which makes it more maneuverable, and is attacking a much larger frigate. This is not as foolhardy as it appears. If you look closer, you'll see another brig closing on the frigate from downwind. In effect, this is a wolf pack tactic. This could easily have been a naval engagement involving the *Minerva* on Long Island Sound during the Revolutionary War.

The *Minerva* was built in Rocky Hill and was commissioned as the first ship in the newly formed Connecticut navy. There was no Continental navy until one was authorized by the Continental Congress on October 13, 1775. In the absence of a strong centralized government and a powerful national navy, the colonies began to look to their own defense. The Connecticut Council of Safety authorized a warship to be built. The *Minerva*, a 108-ton brig armed with sixteen guns, was completed by Captain William Griswold on August 3, 1775. Brigs were two-masted vessels, with the taller mast on the stern; both were square-rigged masts, usually with a spanker sail in the stern and one or more foresails.

Griswold was a prominent merchant, shipbuilder and sea captain from Rocky Hill. He ran away to sea as a boy and settled in London as an apprentice sail maker. In 1762, he returned home to Rocky Hill in command of his own ship.

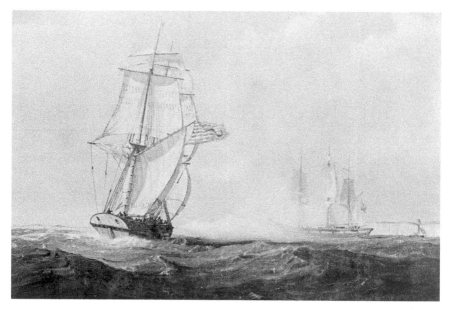

A brig going into battle. *Courtesy of the Rocky Hill Historical Society.*

In October 1775 the *Minerva* was ordered to sail to the mouth of the Saint Lawrence River to intercept British vessels bound for Quebec. This was in support of the attack on Quebec, led in part by Benedict Arnold (he was on the side of the Americans at the time). Nearly all the crew and soldiers on board mutinied and refused to sail this far from home to fight in Canada. Even when the old crew was discharged and a new crew recruited, the *Minerva* remained in port. Finally, the brig was returned to Captain Griswold without having fought as of December 1775.

Despite this rocky beginning, the *Minerva* proved to be invaluable during the American Revolution. In January 1776, the *Minerva* was once again in the service of Connecticut. This time, it completed a six-month cruise under Captain Ephraim Bill. Griswold again received his vessel in June 1776.

A third period of state service took place in 1778. William Griswold again outfitted the *Minerva* as a warship and sold it to the state in April 1778. Then, in 1781, it became a vessel of the Continental government. This seems to have ended its service as a naval ship. Very little is known of its cruises from 1776 to 1781.

It was as a privateer that the *Minerva* had the greatest impact. Adam Babcock and Company owned the brig in 1781, when it set out on a privateering voyage under Captain Dudley Saltonstall. It proved to be a

very successful cruise. On June 24, 1781, the *Minerva* captured the British privateer schooner *Arbuthnat*, with ten guns and a valuable cargo of tobacco.

In 1783, the *Minerva* captured the *Hannah*, with sixteen guns and a cargo worth about $400,000. It proved to be the richest prize taken during the American Revolution. This had severe consequences. The British were frustrated during the Revolutionary War by Connecticut privateers. The privateers were, in effect, state-licensed pirates. Connecticut privateers were usually shallow-draft ships that could attack British shipments and then duck into rivers that were protected by shallow bars, so the larger British ships of war couldn't follow.

The capture of the *Hannah* so angered the British that they sent Benedict Arnold (on the side of the British by this time) to attack and burn New London. The Thames River is deep at its mouth, so New London was easier to attack. Arnold was from Norwich and seemed to take particular joy in damaging and punishing the homefolks. He also destroyed much of Connecticut's maritime history by burning down the New London Customs House, where most of the state's maritime records were kept.

Samuel Broome and Company owned the *Minerva* during its final privateering voyage. This time, Captain James Angel was in charge. Angel was able to recapture the American brig *Rose*, which the British privateer *Experiment* had captured.

There is a historical anomaly associated with the *Minerva*. The ship on the town seal and on the reliefs on the outer walls of the town hall are sometimes claimed to be the *Minerva*. The ship seems to be a frigate; the *Minerva* was a brig. There is no record of frigates ever sailing to or from Rocky Hill, and given the difficulty of sailing the *Glastonbury Meander* in the Connecticut River, it is unlikely that any ever did.

DID GEORGE WASHINGTON SLEEP HERE?

G eorge Washington slept here" has become a common cliché in the history of small towns and a marketing tool for old inns on the East Coast. If Washington had slept in all these places, he would have spent most of his life in the arms of Morpheus. Washington visited Connecticut five times: in 1756, 1775, 1780, 1781 and 1789. Here's what we know about Washington's visits.

Washington traveled though Connecticut in 1756, during the French and Indian War. He went to Boston to ask Governor William Shirley, the acting commander in chief, to obtain a royal commission in the British army. He traveled on the Lower Post Road, stopping in New Haven and New London, but it doesn't seem like he went through Rocky Hill on this trip. He didn't get the commission he wanted, but it was decreed that Virginia militia officers outranked British officers of lower rank.

According to a March 12, 1932 article in the *Middletown Press*, Washington passed through Durham twice: once on Thursday, June 29, 1775, and again on Monday, October 19, 1789. In 1775, while seeking provisions for his army, Washington stopped on the east side of Main Street at Mill Hill in Durham to briefly visit with General James Wadsworth, who became a major general of militia and the second-highest ranking militia officer in Connecticut. After leaving General Wadsworth, Washington proceeded along Main Street. He stopped at the north end of town at John Swathel's tavern, probably to obtain fresh horses. Washington's diary tells us that he "then proceeded to Wethersfield, after passing through Durham." According to the *Middletown Post* article, he stayed at Silas Deane's house

George Washington.
Courtesy of the Library of Congress.

in Wethersfield on the 1775 trip. The most obvious route from Durham to Wethersfield would have taken him north on Main Street in modern Rocky Hill, to Church Street, and up what is now Old Main Street to Wethersfield. No record has been found of him stopping in Rocky Hill. You have to ask: why would he have stopped two miles from his destination, Silas Deane's house, when his goal was to get to Boston as quickly as possible?

Washington and French general Rochambeau met in Hartford in September 1780, about halfway between Rochambeau's headquarters at Newport, Rhode Island, and Washington's camp in New Windsor, New York (on the Hudson River, just south of Newburgh). Their talks didn't get far, as the threat of a British attack broke up the meeting. Both generals traveled with large entourages. Washington's entourage spent a night in Ridgefield, Connecticut, and went to Hartford by way of Farmington and Newington. His route would have had him entering Hartford from the northwest. It seems unlikely that he took a circuitous route and went through Rocky Hill either coming or going on this trip.

Washington and Rochambeau met again in Wethersfield on May 21 and May 22, 1781. There was no place to stay in Hartford, as the Connecticut legislature was in session, so they chose the town of Wethersfield nearby. According to the article "SAR Pilgrims Go to Rocky Hill," *Hartford Courant*, June 29, 1914, the two generals stayed at the Joseph Webb house and had their conference in Wethersfield at Stillman's tavern, which stood, until a few years ago, where the house of Deacon R.A. Robbins now stands on Broad Street Green. It is said that the two commanders each brought an entourage of about thirty people. Some of their aides stayed with the villagers. It was at this meeting that the generals agreed to launch a coordinated attack on Lord Cornwallis's forces at Yorktown, Virginia. Again, Washington traveled from New York in the northwest to Hartford. Rochambeau approached from the northeast. There was no reason for them to travel through Rocky Hill.

Washington passed through New England again in 1789. According to the Frederick W. Smith Library for the Study of George Washington at Mount Vernon:

George Washington went on his New England tour from October 15 to November 13, 1789, during the first Congressional recess under the new

federal government. He travelled from New York City, then the capital of the United States, through Connecticut, Massachusetts, and New Hampshire. He visited nearly sixty towns, stopping along the way to visit factories, talk with farmers, and partake in celebratory festivities. From Washington's perspective, it was a fact-finding and promotional tour. In large part, Washington intended the tours to rally support for the Constitution and promote a strong central government in the face of fierce state loyalties.

The only company Washington had on the New England Tour was his personal secretaries Major William Jackson and Tobias Lear. In addition, six of his slaves accompanied his carriage.

He travelled in his carriage and stopped at farmhouses along the way, where he discussed agricultural practices with the inhabitants. Just before entering a new town, Washington left the carriage and rode in astride his great white charger, usually accompanied by the local militia. In the towns, he met with municipal and state politicians, reviewed militias, and toured local sights.

While on the tour, Washington refused to lodge in private homes and instead insisted on paying for lodging at taverns and public houses.

At the time, a journey to Boston involved horses on poor roads, accommodations that ranged from good to primitive, early rising and hard travel. You might cover thirty miles in a day with stops for meals and lodging. Washington's party left New York on October 14, 1789. They reached New Haven on October 17 and left the following morning, traveling through Wallingford and Durham to Wethersfield. Having dined in Wallingford, they set out for Hartford. Passing through Middletown and Wethersfield, they arrived at Hartford about sundown. At Wethersfield, they were met by a party of the Hartford Light Horses, and from there, with Colonel Wadsworth at their head, they were escorted to Bull's Tavern, across Main Street from the Old State House, where they lodged.

According to the article "SAR Pilgrims Go to Rocky Hill":

One of the more attractive Colonial houses in Rocky Hill is the old Robbins house, halfway between South Wethersfield depot and Rocky Hill Center. This house is supposed to have been a resting place of Washington's when it was a tavern known as the Duke of Cumberland. At the Chicago World's Fair, an autographed letter from Washington to one of his officers dated "The Duke of Cumberland Inn," was on exhibit.

Washington returned to New York by a slightly different route, going through other Massachusetts towns, arriving quietly in Hartford on November 18. Washington's diary says, "Left Hartford about seven o'clock and took Middle Road (instead of the one through Middletown, which I went). Breakfasted at Worthington in the township of Berlin at the house of one Fuller. A fairly large company of ladies and gentlemen were present."

Worthington Ridge in Berlin is near the intersection of the Berlin Turnpike and Route 9. There is no mention of Rocky Hill or the Duke of Cumberland Inn in Washington's diaries.

So, what was Washington's experience in Rocky Hill? It seems certain that he traveled through Rocky Hill in 1789 and probably stopped to rest here and prepare for his entrance into Wethersfield. There seems to be little question that he traveled on the Hartford–Saybrook Turnpike, which ran north on Main Street in Rocky Hill, north up church Street and north up Old Main Street to Wethersfield. If you live on one of these streets, Washington certainly rode past your house. The records show that he typically stopped at taverns and inns outside of population centers for refreshment and to transfer from his carriage to his white charger so that he could make an impressive entrance into the population center. The records show that he was greeted with pageantry in Wethersfield by Jeremiah Wadsworth, the first representative to Congress from Hartford, and the Hartford Light Horses, and they escorted him to Bull's Tavern in Hartford. A 1914 *Hartford Courant* article states that Washington sent a letter from the Duke of Cumberland Inn in Rocky Hill. A puff piece in the local paper can't be considered solid evidence; however, consider the road from the Duke of Cumberland Inn into Wethersfield. The road is a long hill, ideal for a national hero's parade into town on a stately white horse.

ROCKY HILL'S REVOLUTIONARY SLAVE

As we continue to dig into our history, we discover some remarkable people. One of these people was Caesar Freeman. Caesar's history was discovered while the author of this book was doing a title search and genealogical workup of people who owned parts of Straska Farm in West Rocky Hill, in support of the town's decision to buy the land for farming and historical preservation.

Caesar was born in 1757. He was enslaved by Elias Williams. In August 1780, during the Revolutionary War, he was manumitted to serve in Williams's Company, Webb's Regiment, as a substitute for Elias Williams. (*Emancipation* is the process of freeing the enslaved through government action. *Manumission* takes place when masters free their enslaved people voluntarily).

Elias Williams was a master and/or owner of several ships that were launched from Rocky Hill. He owned the house at 1 Pratt Street that still exists at the corner of Pratt Street and Dividend Road. Like many of Rocky Hill's sea captains, he was a slave owner. According to the *History of Ancient Wethersfield*, at various times, he owned enslaved people named Dick Durbin and Frank (last name unknown). In his will, Elias Williams bequeathed an unnamed "negro woman" to his wife.

It is telling that, with occasional exceptions, these enslaved people, euphemistically called "servants," weren't identified by family names. In some cases, they took their owners' names. In some records, their family

Elias Williams House. *Courtesy of the Rocky Hill Historical Society.*

name is simply "Negro." In other cases, they are given no surname. Timon was another enslaved person who was freed to serve in the Ninth Connecticut Regiment. He is never identified by a surname and is listed simply as Timon. Many African Americans are rightfully angry that their genealogy and heritage has been obscured or erased by this casually racist trivialization. Caesar chose the name Freeman, as many freed slaves did, to announce that he was free, or no longer enslaved.

Caesar served in the Ninth Connecticut Regiment. The regiment was involved in the Battle of Springfield, New Jersey, in which the British attempted to penetrate the Continental army's camp at Morristown and were repulsed. His regiment was generally active in the defense of Connecticut, southern New York and northern New Jersey. It was merged with the Second Connecticut Regiment in January 1781.

Caesar was discharged in 1783 and, apparently, returned to Rocky Hill as a free man. We haven't been able to learn much about the next twenty-two years of his life. We know he had a wife who died in 1810 and that he was then married to Lemon Harrison in 1810. In 1805, he purchased a farm that would eventually become part of present-day Straska Farm between New Britain Avenue, New Street and France Street. This was quite an accomplishment for a manumitted enslaved person. He moved to Oneida County, New York, and sold most of his property in Rocky Hill in 1819.

He sold his last piece of property in Rocky Hill, which was probably the farmstead, in 1822.

Caesar filed for a Revolutionary War pension in Oneida, New York, in 1820. He described himself as a farmer but said he was without land and in poor health. His pension application reads as follows:

> *State of New York*
> *Oneida County*
>
> *Caesar Freeman, being duly sworn, sayeth that he is a resident of the County of Oneida and State of New York. That he is sixty-one years old and upwards. That by reason of his reduced circumstances in life, he is in need of assistance from his country for support. That he never had any pension allowed him by the laws of the United States. That he served as a soldier in the War of the Revolution in the Continental Establishment three years. That he enlisted in 1780 in William's Company, Webb's Regiment, Connecticut Line, and served therein 'till the end of the war in 1783, when he was honorably discharged as appears by the discharge signed by General George Washington, hereto annexed. The discharge is genuine and originally granted to this deponent.*
>
> *Sworn this 9 April 1818*
> *Before me*
> *H.J. Miller*
> *District Judge of Oneida*

There is no mention of a wife or children in his pension application. Caesar Freeman died on June 6, 1833.

BENJAMIN FRANKLIN'S MILE MARKERS

D efinition, *milestone*: "A stone set to indicate the distance or space of a mile or the number of miles from a given point. Used to lay out postal routes."

If you take a ride south from Rocky Hill's northern town line, along Old Main Street and Main Street, you'll find four brownstone markers along the way. These are milestones that demarcate what used to be the Hartford–Saybrook Turnpike in Rocky Hill. Ed Chiucarello of the Rocky Hill Historical Society looked into these markers; he even found them, cleared away brush and cleaned them.

According to an article in the September 11, 1960 edition of the *Hartford Courant*, Benjamin Franklin, who was the postmaster general from 1753 to 1774, spent the entire year of 1764 laying out highways in Connecticut. He used a meter on the wheel of his wagon to accurately measure one-mile distances and designate locations for markers. Although he didn't invent this meter, he made improvements to it. There were claims that Benjamin Franklin oversaw the actual placement of these markers. He died on March 17, 1790, and the turnpike was completed in 1802, so this can't be true. He did, however, determine the turnpike's design. The Benjamin Franklin Historical Society, a part of the University of Massachusetts History Club, confirms this information.

Prior to the Civil War, there were five hundred milestones in Connecticut. Many of the milestones were taken away by collectors, and some succumbed to the ravages of time. In 1931–32, the state highway

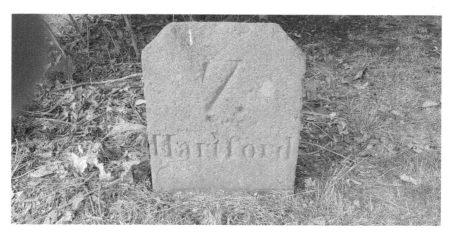

Mile marker. *Author's collection.*

department restored many of the milestones on this turnpike, but time has again been taking its toll.

Middlesex Turnpike seems to have been a local name for the Hartford–Saybrook Turnpike. The turnpike followed the route of the Lower Middle Boston Post Road, which ran from Saybrook through Middletown, Cromwell (which was a part of Middletown, then called Middletown Upper Houses), South Wethersfield (which became Rocky Hill) and Wethersfield and on to Hartford.

The Hartford–Saybrook Turnpike was a toll road chartered by the Middlesex Turnpike Company. The road began at the south side of Goffe's Brook (now in Rocky Hill) and the southern terminus was located at the Stage Road in Saybrook. There were four toll gates on the road, the northernmost one being the Old Toll House at 3372 Main Street in Rocky Hill, near the Rocky Hill and Cromwell town line. This road ceased to be a turnpike in 1872, one year after the railroad reached Rocky Hill and provided a much more efficient means of transporting passengers and freight.

The milestones on the turnpike seem to have been numbered based on their distances from the Hartford City Line. The first stone in Rocky Hill is milestone VI, six miles from Hartford. According to *History of Ancient Wethersfield*, this was once the site of a grain mill, probably powered by Goffe Brook. Today, stone VI is located in front of 60 Old Main Street.

Using an automobile's odometer, if you drive exactly one mile south, milestone VII is located at the northwest corner of the intersection of Old Main and Church Streets, across the street from the site of the Shipman Tavern, which was torn down and moved to New Jersey around 1934.

Driving exactly one more mile south, there is a lump of brownstone that is almost certainly milestone VIII in front of the Westgate Condos. It looks like a nondescript rock if you don't know its context. There is a more modern cement marker at milestone VII, and one just like it is located at milestone VIII.

Milestone IX is yet to be found. If you drive one mile from this point, you come to the place where milestone IX should be. A photograph in the Rocky Hill Historical Society's collection locates milestone IX near 3205 Main Street, a large undeveloped patch of land covered by undergrowth too dense to penetrate. If you continue exactly one mile into Cromwell, there is no milestone, but there is a street named Freestone Street.

If you drive south on Cromwell Avenue in Rocky Hill, when you cross the Cromwell town line, you'll notice the name on the street sign changes to "Shunpike." This was once the name of the same road in Wethersfield/Rocky Hill, and it denotes that people used this less well manicured road to "shun" the Saybrook–Hartford Toll Road. It's unclear when the name changed in Rocky Hill or why. It is called the Shunpike in *History of Ancient Wethersfield*, which was published in 1904. A 1928 article in the *Hartford Courant* calls it Cromwell Avenue, so the name must have been changed during this period. The old name, Shunpike, conveyed some local historical color, and many town residents still use the name for the road in Rocky Hill.

The Rocky Hill Historical Society is considering starting a project to find, clean and restore these milestones. Randall Nelson, of Nelson Architectural Restoration, has submitted a proposal to restore these pieces of our history. The Rocky Hill Historical Society is looking for people who would like to be involved in protecting and preserving these valuable artifacts, including developing funding strategies for their restoration.

THE BRIG COMMERCE

Shipwreck in Africa

A town's history doesn't end at the town line. The story of the *Commerce* involves people from Rocky Hill, Cromwell, Glastonbury and other Central Connecticut River towns and reaches as far away as the slave markets in the Sahara Desert.

The brig *Commerce* sailed from Middletown, Connecticut (possibly Cromwell, then called Middletown Upper Houses), to New Orleans on May 6, 1815. The crew included Captain James Riley of Cromwell; First Mate George Williams of Middletown; Second Mate Aaron R. Savage of Cromwell; and Thomas Burns of Lyme, Archibald Robbins of Rocky Hill, Cabin Boy Horace Savage of Cromwell, James Clark of Hartford and Richard Delisle, an African American cook from Hartford. Francis Bliss and James Carrington left the ship in New Orleans before its departure for Gibraltar, and they were replaced by William Porter and John Hogan of Massachusetts.

Two books that cover this voyage were written in the nineteenth century by men who were on the voyage. They are both available online at no cost and are downloadable from www.archive.org. They make a fascinating read.

Captain James Riley wrote an account that is available at www.archive.org. This book was a best seller when it was published, selling over 1 million copies, which was quite remarkable for the day. This book was ghostwritten for Riley by Anthony Bleecker of New York. Among its admirers were Abraham Lincoln, Ralph Waldo Emerson and Henry David Thoreau.

Captain Riley began his seafaring career at the age of fifteen as a cabin boy, and he achieved the rank of chief mate by the age of twenty. In 1808, he got his first taste of being a prisoner during a quasi-war, when his ship, the *Two Marys*, was captured by the French, and he was taken prisoner. This experience was much less harsh than his enslavement by the desert Arabs. He used the time to become proficient in French and Spanish and was released in 1809. He became master of the *Commerce* in April 1815.

Archibald Robbins, an able-bodied seaman from Rocky Hill, wrote another book, which is available at www.archive.org.

The *Commerce* affair wasn't Archibald Robbins's first bad nautical experience. He was a member of the wealthy and prestigious Robbins family of Wethersfield and Rocky Hill. He went to sea with his father in 1808 at the age of sixteen. He was captured by the British in 1813, during the War of 1812, and he was held as a prisoner in Halifax, Nova Scotia. After his *Commerce* experience, he returned to Rocky Hill, married Almira Williams, opened a store and became the town's postmaster. When Almira died, he married her sister Elizabeth and removed to Solon, Ohio, where he again opened a store and became town postmaster. He died there in 1859.

At the time these two books were published, they were both considered adventure stories, but they were also educational resources. In the mid-nineteenth century, Africa was known as "the Dark Continent" because, at the time, little was known about its geography and culture. These books were used by scholars as references in understanding these aspects of the area between thirty-two and sixteen degrees north latitude on the Moroccan coast.

The brig *Commerce* was built at a shipyard at Keeney Cove in Glastonbury and sailed from Middletown, Connecticut, to New Orleans in May 1815 to procure a load of freight (flour and tobacco) "for a foreign market." It embarked on a forty-five-day sail to Gibraltar. At Gibraltar, the ship took on a cargo of brandy, wine and a large amount of cash for a return trip to New Orleans, and it took on a paying passenger, an old Spanish man named Antonio Michele, a native of New Orleans who had been shipwrecked at Tenerife in the Canary Islands. Its next stop was to be the Cape Verde Islands to take on a load of salt. Captain Riley decided to take a shortcut between the Canary Islands and Morocco. This was a bad decision. The ship got lost in a dense fog and ran aground at Cape Bajador in southern Morocco. The shipwrecked crew was captured, divvied up as slaves by desert Arabs and marched eight hundred miles through the Sahara Desert to Magadore to be ransomed.

An April 4, 1930 article on the *Commerce* shipwreck in the *Hartford Courant* concluded, "A local historian hints that the *Commerce* may have visited the coast of Africa in quest of Black cargo." For some reason, Rocky Hill historians have made several unsubstantiated claims that vessels from this area carried enslaved people as cargo. A March 18, 2004 article in the *Hartford Courant* takes a more realistic approach: "King (who wrote a fictionalized account of this incident) says there were rumors at the time that the *Commerce* was intending to pick up slaves to bring to the West Indies, but he finds the evidence unconvincing and strongly doubts that was the case."

Hints and rumors aren't history. Both Riley and Robbins described the *Commerce*'s cargo as liquor and one paying passenger. The *Amistad*, which was about the same size as the *Commerce*, carried fifty-three enslaved people. It seems unlikely that fifty-three marketable enslaved people would have disappeared from the records and not be mentioned in any recounting of the *Commerce* story. It should be noted that, according to both books, the *Commerce* didn't visit any port where enslaved people could be taken on. It should also be noted that the slave trade became illegal for Americans and the British in 1807, so if slaves had been aboard, no one was talking about it. It should also be noted that the desert Arabs routinely enslaved Black Africans and would have enslaved any they found aboard the *Commerce*.

The story of the *Commerce* is too big to cover in one chapter. This chapter describes the voyage of the *Commerce*. A second will cover the harrowing story of the crew being captured, enslaved, tortured and abused in the Sahara Desert.

THE BRIG COMMERCE

Slavery in Morocco

This is the second installment of the saga of the *Commerce*, which began with the previous chapter, "The Brig *Commerce*: Shipwreck in Africa."

The people on the *Commerce* when it wrecked on the coast of Morocco were Captain James Riley of Cromwell; First Mate George Williams of Middletown; Second Mate Aaron R. Savage of Cromwell; and Thomas Burns of Lyme, Archibald Robbins of Rocky Hill, Cabin Boy Horace Savage of Cromwell, James Clark of Hartford and Richard Delisle, a cook from Hartford. Francis Bliss and James Carrington left the ship in New Orleans before its departure for Gibraltar and were replaced by William Porter of Massachusetts and John Hogan of Massachusetts.

After the shipwreck, it quickly became clear that the *Commerce* was too badly damaged to repair. The crew salvaged as much water and provisions as they could and began working to make the ship's leaky longboat seaworthy. The work was not completely done when an elderly Arab man elbowed his way in and began helping himself to the crew's meager supplies. He left but later returned with an armed and threatening group of men and ululating women. Captain Riley attempted to negotiate with these menacing people but to no avail.

The crew ran to the boat and pushed off. Antonio Michele didn't make it and was brutally tortured because the Arabs thought he knew where some money buried by the crew was located. Captain Riley remembers him being killed on the beach, but Archibald Robbins and other crew members remember him being carried off by the Arabs.

The longboat didn't have the navigation equipment necessary to sail back to the Canary Islands, so the men decided to sail south, hoping someone would spot them and rescue them. After nine anxious days, they ran out of food and water and came ashore two hundred miles farther south, landing at Cape Barbas, starving and dehydrated. The shore where they landed was surrounded by high cliffs. The men started to dig holes in the hopes of finding groundwater, and Captain Riley climbed the cliffs, only to find a vast expanse of barren, sandy desert. His crew joined him, and together, they started to walk inland, hoping for rescue by a friendly tribe. After enduring 120-degree-Fahrenheit heat during the day and freezing temperatures at night, and after running out of food and water, it became clear to the men that they must either accept death or offer themselves as slaves to the first tribe they encountered.

Eventually, a large group of men and camels appeared on the horizon, and the crew approached them. The crew were menaced with scimitars, muskets and spears and stripped of their clothes. Pleas for water fell on deaf ears. The tribe members fought among themselves to determine who would enslave the men. Riley's crew became separated; they were taken as slaves by different groups, who then went their separate ways.

The captives were entirely dependent on their captors for their survival. The desert Arabs belonged to several tribes who raided one another and stole each other's property. The captives might become subject to new masters at any time, creating a constant air of uncertainty.

All of the captives, although they were dispersed, seem to have followed a similar route, possibly a trade route for captives going to Magadore (now Essaouira) to be offered for ransom. The captives were forced to make their trek in the severe desert heat either naked or scantily clothed. Their skin was burned and blistered and often chafed raw and bleeding as a result of rubbing against the camels' thick, abrasive hides. Their food often consisted of desert snails they were able to gather and occasional scraps their captors gave them. Their hydration consisted of drinking their own urine or that of the camels, which they caught in their bare hands. Their captors considered them infidels (unworthy people), and their only interest in keeping them alive was the hope of selling them as slaves or ransoming them and turning a profit. They had little interest in providing for the captives' upkeep, and if the captives died, it was the will of Allah. Captain Riley, who weighed 240 pounds before the shipwreck, weighed less than 90 pounds when he reached Magadore. He was reduced to a mere skeleton when his captors decided to protect their investment and provide him with basic medical attention and enough food to keep him alive.

During his captivity, Captain Riley developed rudimentary skills in his captors' language, just as he had done during his captivity with the French. He was taken to a place called Wandinoon, thirty miles south of Magadore, where Arabs conducted trade. Riley convinced two Arabs to buy him and his men and take them to Magadore for ransom. Their ordeal abated somewhat on the trip to Magadore, as the captors started to treat their captives better in anticipation of a payday.

William Willshire was a British vice-consul in Magalore, Morocco. One of his duties under the Anglo-Moroccan Treaty was to ransom British and American citizens who had been taken by the Arabs as slaves. There were a large number of Caucasian slaves in the Arab world at this time. Many were taken as prisoners by the Barbary pirates. Robbins encountered several Caucasians during his captivity and holding them for ransom seems to have been a sort of industry for the Arabs. Since most, if not all, of the *Commerce* captives had arrived in Magalore, it seems reasonable to suppose that the Arab captors knew about Willshire and were delivering the crew to him for ransom. The Moroccan who had become Riley's master, Sidi Hamet, approached Willshire to act as a broker in ransoming Riley and some of his crew members. The ransom was executed successfully. Riley and four other crewmen were delivered to Willshire.

Willshire had established himself as one of the leading British merchants in Morocco. Riley and Willshire seem to have hit it off during Riley's convalescence, and they subsequently became business partners in an export business between Morocco and the United States.

When Captain Riley was ransomed and left Magadore, First Mate Aaron Savage and Cabin Boy Horace Savage were ransomed with him. Clark and Burns had left for home previously.

On his return home, Captain Riley was entertained by Connecticut senator Samuel Dana and Secretary of State James Monroe. The federal government provided $1,842 as a reimbursement for the survivors' ransom and promised to ransom the remaining captives should they ever be found.

Riley removed to Ohio and established the town of Willshire, Ohio, which he named for his emancipator and business partner. He named his first son William Willshire Riley. Riley was active in Ohio politics, serving in the Ohio State Legislature. Health problems caused him to return to Cromwell, and he resumed seafaring in 1826. He died at sea on March 13, 1840, at the age of sixty-three.

When Archibald Robbins, the other chronicler of the adventure, was captured, he was stripped of his clothes and given a strip of blanket about

eighteen inches wide to tie around his waist. His new master also acquired two other slaves, First Mate George Williams and Ordinary Seaman James Barrett. These companions provided him with some level of comfort and solace, but another group of Arabs attacked the first and stole his companions away.

After eighteen days of torture and horrible privation, Robbins's group united with another group of Arabs who were holding Captain Riley, Second Mate Aaron Savage, Seaman James Clark, Seaman Thomas Burns, and Horace Savage, the cabin boy. Captain Riley told him they were being taken to Wandinoon, where they would probably be ransomed (although he had no assurance that this would happen), but to Robbins's despair, the Arabs again traded them and departed in different directions.

Robbins was resold to several masters in his travels and crossed paths with his fellow captives several times. Robbins eventually arrived at Magadore, where he was sold to a third master. He reconnected with Seaman William Porter. Porter was ransomed after fourteen months in captivity. Robbins was ransomed five months later, after spending two years in captivity.

After three months of wandering in the desert, of the thirteen people who survived the wreck, only seven were ransomed. The ransomed were Captain James Riley, William Porter, Aaron R. Savage, Thomas Burns, James Clark, Archibald Robbins and Horace Savage. The fates of John Hogan, James Barrett, George Williams, Richard Delisle and Antonio Michele are unknown.

A fictionalized book by Dean King, based on the *Commerce* incident, was published in 2004. A film, *In Sand and Blood*, has been made, but King sued the creators of the film for copyright infringement.

It should be noted that the content of the chapters "The Brig *Commerce*: Shipwreck in Africa" and "The Brig *Commerce*: Slavery in Morocco" is based on Riley's and Robbins's books and a 1922 newspaper article based on an interview of William Willshire Riley, James Riley's son, conducted by Frank K. Hallock, MD, of Cromwell, Connecticut.

CANALITES AND RIVERITES

D uring the eighteenth century, roads were poor. Although stagecoaches and freight wagons were common modes of transportation, rivers and large lakes provided the primary transportation avenues. For most of the eighteenth century, Rocky Hill enjoyed a privileged position as one of the best northernmost landing points on the Connecticut River for seagoing vessels. It was a construction center for sailing ships and enjoyed the benefits of being the home of the ferry across the Connecticut River to Glastonbury.

At the beginning of the nineteenth century, an effort was made to construct what were called internal improvements. The steamboat *Claremont* was launched on the Hudson River in 1807. The Erie Canal was completed in 1821. These two innovations revolutionized transportation and started a boom in steamboat construction and canal digging. Things were changing on the Connecticut River. As early as 1770, there were people working to put navigation markers in the river and dredging it to open navigation upriver to Hartford and beyond. By 1790, dredging and other improvements had begun on the most hazardous points in the river. The pressure exerted by interests in Hartford ensured that further improvements would be made.

Ingenuity was in full bloom, as new technologies were introduced and applied to transportation. Sadly, the few powerful interests who controlled the Rocky Hill Riverfront didn't take the lead or even keep up with the changes. They opposed navigation improvements and the replacement of sail with steam. They knew how to overcome the hazards of the river and weren't open

to the increased competition improvements would bring. Moreover, they were heavily invested in sailing ships and were reluctant to retool for steam.

Other Connecticuters, called canalites, were involved in some dramatic innovations. Among these innovations was the construction of another waterway, the Farmington Canal from West Haven, Connecticut, to Northampton, Massachusetts, with plans to extend it to Lake Memphremagog in Vermont.

River interests, called riverites, responded. Why dig a canal when a perfectly good waterway, the Connecticut River, existed? The steamboat *Barnet* was the first steamboat to traverse the Connecticut River in 1826. It was towed over the Enfield Falls and went as far north as Barnett, Vermont (the town that was named for it). The river proved to be a strong alternative to the Farmington Canal. The river was improved through dredging and the construction of locks to bypass the Enfield Falls. The town of Windsor Locks was named for those locks.

A steamboat dock existed in Rocky Hill for a while in the mid-nineteenth century, but the town had ceased to be a significant commercial port, and the dock became the coal dock used to unload coal, primarily for the foundry.

The competition between the canalites and the riverites was so intense that none of them heard the *toot-toot-toot* of the train whistle. Why churn up a river or canal for days at a time when you could load your passengers and cargo aboard a train and deliver them upstate or downstate in a matter of hours? The rivers and canals routinely froze in the winter, while the railroads were open year-round, except in the most extreme weather.

Rocky Hill heard the train whistle and responded, demanding a stop on the Middletown/Hartford Railroad as early as 1854. The Valley Railroad began stopping in Rocky Hill in 1871. This provided a boost to Rocky Hill's economy. Industry was booming in South Glastonbury, and a train could take advantage of the Rocky Hill–Glastonbury Ferry to pick up and unload cargo originating on both sides of the river. The railroad operated in Rocky Hill until 1975 and resumed operations on a limited basis in 2020.

As with all stories of our history, there are still echoes and remnants of the time of canalites and riverites. There are places you can go and things you can see that reference these groups. Try searching online for "Farmington Canal Heritage Trail" to hike or bike remnants of the Farmington Canal. Search "Windsor Locks Canal" to find parks and hiking and biking trails. Visit the Rocky Hill Riverfront (Ferry Park or Surwilo Park are good). Fire up your imagination and try to recreate what it was like in Rocky Hill two hundred years ago.

YANKEE PEDDLERS

Yankee peddlers are an example of Yankee ingenuity. Just as the seafarers on the Connecticut River recognized the value of their towns' goods, found a market for them and developed a means of conveyance, so did the Yankee peddlers. Just as ships sent Rocky Hill's goods to other ports, the Yankee peddlers loaded goods brought on ships from exotic places onto their wagons and carried them to receptive customers. Their wagons carried products around the country.

There are several stories about where the term *Yankee* came from. The most credible is that it was used scornfully in the 1600s when English and Dutch settlers clashed at the Connecticut–New Amsterdam border. It is unclear who first called who what, but the word seems to be derived from a group of people who were called *Jan Kees* or *John Cheese*, meaning country bumpkin. The word came to apply to Connecticuters, who seemed willing to take it as a badge of honor. By the start of the French and Indian War, the term had expanded to include all New Englanders. During the Civil War, Confederates used it a pejorative for all northern people. During World War II, all Americans became Yankees or Yanks. It has also become the name of a regional baseball team.

Yankee peddlers got their start in Berlin, Connecticut, when, in the 1740s, the Pattison brothers, Irish immigrants, established themselves as tinsmiths and sent sales representatives up and down the East Coast to hawk their wares. The Danforth family, who were based in Norwich, Connecticut, at the time, followed suit. The practice soon spread to surrounding towns, and the wagons of Yankee peddlers were soon rolling along roads up and down

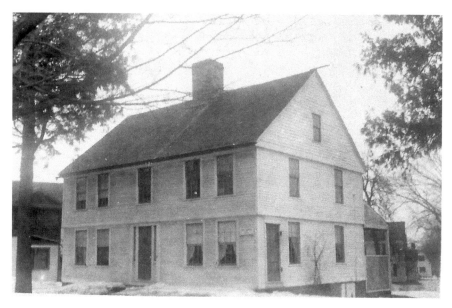

Danforth House. *Courtesy of the Rocky Hill Historical Society.*

the East Coast. The Danforths relocated their operations to Rocky Hill in the mid-eighteenth century and took up residence at 826 Old Main Street. Our town soon became home to many Yankee peddlers.

The typical Yankee peddler evolved from being a commissioned salesperson who specialized in one product to an independent entrepreneur who obtained goods on consignment; loaded them into specially built, efficiently loaded wagons; and, most often, sold them to individual housewives along the route.

These peddlers can be credited with Connecticut's unofficial nickname, the "Nutmeg State." Early Connecticut sailors would bring this valuable spice back from their foreign voyages, and Yankee peddlers included it in their wares. The story is that some customers, especially those in southern states, challenged the honesty of Yankee peddlers, accusing them of carving fake nutmegs out of wood. (Damn Yankees!) Nutmegs have a hard shell that has to be removed so you can get at the grateable insides. It has been suggested that southern customers were unaware that they had to remove the shell from these spices to grate them. They may have tried to grate the hard shells instead and wrongly thought that the Yankee merchants had cheated them.

During the Great Depression, there was an expression, "Don't take any wooden nickels," to warn people to be careful in their transactions. If this author had lived in the nineteenth century, I would have advised our southern friends, "Don't take any wooden nutmegs."

THE DANFORTH PEWTER SMITHS

C aptain Thomas Danforth II came to Rocky Hill from Middletown in 1778. He was a veteran of the Revolutionary War. He settled at the Danforth House at 826 Old Main Street, which still exists at the northeast corner of Old Main Street and Glastonbury Avenue, and set up shop there. This site became the hub for a far-flung network of businesses. He manufactured pewter and tin goods, mostly for the southern trade, using horsepower for his machinery. He was a principal businessman in Rocky Hill from 1778 until 1818. He continued in trade here—either by himself or through his son Thomas Danforth III—until he died in 1840 at the age of eighty-four.

The genealogy of the Danforth family is a little muddy. Documents identify Captain Thomas Danforth and his son Thomas by various names. Captain Thomas is sometimes called Thomas Danforth III; his son is listed as Thomas Danforth III, IV and Junior. In fact, Thomas's grave inscription lists him as Thomas Danforth Jr. Genealogy research reveals three Thomases: one born in 1703 and died in 1786; his son, born in 1756 and died in 1840; and his grandson, born in 1792 and died in 1836. Captain Thomas Danforth was Thomas Danforth II; his son was Thomas Danforth III.

Thomas Danforth II has been credited with establishing America's first chain store system, with branches in Philadelphia, Atlanta and Savannah. He spent a number of years traveling between Connecticut and Philadelphia, where his son Thomas Danforth III served his apprenticeship. Danforth dispatched Yankee traders around the country. His account books show that

he dealt in almost every conceivable article of hardware then known. He'd carry anything you could buy that fit in his wagon. He also manufactured all sorts of tin, Brittania (a glossy, smooth-surfaced pewter alloy), pewter and japanned goods (a japanned finish is one in which the metal is coated in a shiny black or very dark gray coating, and often, this finish has a lustrous, black lacquer over the top of it), as well as those of copper, brass and lead. He had a brother in Hartford and another in Middletown, both engaged in the same line of manufacturing.

One of Danforth's revenue streams describes a housekeeping custom of the 1800s. Danforth's accounts contain frequent records of sales of sand to the town's people. This was for sanding the floors in family sitting rooms and other rooms. Carpets were not in general use in the early nineteenth century, and fine, white, imported sand was used to sprinkle over the floors. When it was swept up, it took up all sorts of dirt and dust. It was left on the floor for several days, then swept out before a new sprinkling was put on. It was commonly used in barrooms, stores, barbershops, et cetera. This use of sand continued as late as 1840.

Ashbel Griswold, a native of Rocky Hill (born in 1784) was one of Thomas Danforth II's most successful apprentices. In 1808, he went to Meriden, began making tin goods and ultimately became one of the first promoters of the Brittania ware industry. He became, arguably, better known than the Danforths themselves. He died in 1853, wealthy and respected.

Another apprentice of Thomas Danforth III was Sherman Boardman of Hartford and the old and well-known Brittania firm of Boardman and Hart of New York. He was also a direct descendant of the old Rocky Hill Shop. Lucius Hart, also an apprentice of Thomas, was raised in Rocky Hill.

The last of the Danforth family left Rocky Hill around 1870. Danforth Pewter has been doing business in Middlebury, Vermont, since 1980. Their website is www.danforthpewter.com. An exhibit of Danforth and Ashbel Griswold metal ware was recently found and is viewable at the Smithsonian Institution. Several Danforth artifacts are viewable at the Rocky Hill Historical Society.

GOLD IN THEM THAR HILLS

D
on't you sometimes wish you could stand in a place where something historical happened and have the ghosts of that place tell you their stories? There was once a farm, the Kelley-Dowling Farm, where the Arburg Company now stands on the south side of West Street, north of Gilbert Avenue. If you could communicate with the ghosts there, they could tell you stories of four young brothers who fled the infamous Irish potato famine, toiled on a farm in Cromwell, worked as miners in the Portland Brownstone Quarries, experienced the height of the California Gold Rush and owned a prosperous farm on West Street for many years. Two of the brothers, John and Michael, were local legends for many years, although few people remember them in 2021.

The four Dowling brothers—Daniel, Michael, John and Dennis—came to Connecticut from Queen's County, Ireland, in the 1840s, at the height of the potato famine, to work as farmhands in Cromwell and as workers in the Portland Quarries. This couldn't have been a particularly exciting time for four young men who had come to America to seek adventure and fortune.

The Dowling brothers set out for California in 1850, at the start of the California Gold Rush. There was no easy way to get from Connecticut to the California gold fields back then. You could go by wagon across the Oregon Trail, but this was a long, arduous, dangerous trip. You could sail around Cape Horn, a difficult and dangerous sail. Or you could take

Gold rush miners.
*Courtesy of the
Library of Congress.*

the route the brothers took—they crossed the dense jungle that was the Isthmus of Panama and caught a steamboat to San Francisco.

The Dowling brothers had several sobering experiences in California. Upon their arrival, they were captured and held hostage by Natives for three days. Vigilantes were the only law during the gold rush, and justice was spotty. Many vigilantes were just as bad as, or worse than, the lawbreakers they pretended to oppose, and everyone carried a gun for personal protection. The Dowlings saw many ad hoc hangings—mostly for killings or claim jumping. These were common during the gold rush. Gold was plentiful, but even the most common, basic things were extremely expensive. For example, moldy biscuits were sold for a dollar a pound. Many people, including, apparently, the Dowling brothers, set up an in trade, or "mining the miners," as it was called.

Daniel was killed in an accident in California. The remaining Dowling brothers returned to Connecticut via the Isthmus of Panama in 1859. They hadn't struck it rich, but they had acquired enough money through mining miners and other means to start businesses back on the East Coast.

The Dowling Farm was located on the south side of West Street, west of Gilbert Avenue, where the Arburg Building is located today. In 1860, Michael Dowling bought the farm, known then as the Kelley Farm on West Street, from Moses R. Beach of Wallingford. He later sold a half interest to his brother John. Dennis showed no interest in farming. He ran a store in Crowell for a while and then returned to California and married a Californian woman.

As a historical footnote, the Kelley-Dowling Farmhouse has another claim to history. A man named William Kelley hosted the first Roman Catholic

services in Rocky Hill at the Kelley-Dowling Farmhouse in 1853, while the Dowlings were seeking their fortune in California.

Michael lived to be 102 years old and served as a Rocky Hill selectman for several years. He died in 1918. John lived to be 101, dying in 1923. Michael died with no children; John had four daughters and a son. The farm passed into the possession of Henry W. Dowling, John's son. Henry sold the farm in 1958 to Roscoe H. Gardiner and Marshal L. Gardiner of Rocky Hill.

ROCKY HILL IN THE CIVIL WAR

The Civil War began in April 1861. By the end of the war, in April 1865, Rocky Hill had sent 128 soldiers to fight. The population of Rocky Hill was 1,102 at the time so, given that the town's families were tightly interrelated, it's safe to say that everyone in town had at least one loved one in jeopardy in the war. Several Rocky Hill men died as a result of battle and in the Confederate prison camps.

Many of Rocky Hill's Civil War soldiers served in the Sixteenth Connecticut Volunteer Infantry, which was raised in the late summer of 1862. It was one of the Union army's particularly ill-fated units, and it gained the sobriquet the "Bad Luck Regiment." The regiment fought at the Battle of Antietam, even though it was ill-trained and wholly unprepared for combat at the time. Antietam was, arguably, the bloodiest battle of the war. Its consequences were catastrophic and predicable. Then, on April 16, 1864, after a year and a half of service, largely in garrison duty on the coasts of Virginia and North Carolina, the Sixteenth Connecticut Volunteer Infantry was captured en masse at the Battle of Plymouth, North Carolina. Most of the men were sent to the notorious Andersonville Prison Camp, where disease and starvation took a deadly toll. The horrors of those two disasters haunted the survivors until their final days.

Several of Rocky Hill's Civil War heroes were buried in Rocky Hill Center Cemetery. Jarvis Blinn's marker, which had fallen into disrepair, was restored in 2014. Two other Blinns received less attention. Private John S. Blinn was a farmer in Rocky Hill when he enlisted in August 1862. He was discharged

Captain Jarvis Blinn, killed in action at the Battle of Antietam. *Courtesy of the Rocky Hill Historical Society.*

in March 1863 due to wounds he probably received at the Battle of Antietam, and he died in April 1863. Wadsworth Blinn enlisted in April 1861. He became ill, was discharged and died in August 1861. It was not unusual for Civil War recruits to be exposed to new, often fatal, diseases upon entering the military and coming into contact with people from other areas.

The LeVaughn brothers sacrificed much. Roland LeVaughn was a first sergeant who was captured at Plymouth, North Carolina, in April 1864 and died in a prison camp in Charleston, South Carolina, in September 1864. His brother William, also a first sergeant, was also captured in this battle and died at Andersonville Prison. A third brother, Donald LeVaughn, a private, was wounded at Antietam and returned to his home at 22 Pratt Street. He was later married and lived until 1917.

Frederick D. Culver, Lorenzo D. Culver and Otis Culver all served in the Civil War. Frederick was wounded and died in 1862, probably from injuries he received at Antietam. His brothers both died in 1866. Research has yet to determine Lorenzo's and Otis's causes of death, but considering they died one year after the end of the war, their deaths were probably war-related.

Elizur Belden was captured at the Battle of Plymouth and also died at Andersonville Prison Camp.

Eli Rodman served from Rocky Hill in Company G of the Twenty-Ninth Connecticut Colored Infantry. Other Black privates from Rocky Hill who served in the Twenty-Ninth were Nathan Camp and Edward Peters in Company C; John Smith in Company H; and Charles Depth, unassigned.

This overview barely scratches the surface of Rocky Hill's involvement in the Civil War. The Rocky Hill Historical Society sponsors an ongoing project to clean their monuments in the Rocky Hill Center Cemetery. As we clean the stones, we are discovering new facts about our forbearers and their histories.

THE LEGACY OF ELI RODMAN

li Rodman's story is one of overcoming adversity. He was a Black Civil War veteran from Rocky Hill. He was born in 1825, so at thirty-nine years of age, he was quite old to be a military recruit. He served in the Twenty-Ninth Infantry Regiment, U.S. Colored Troops, from April 1864 to November 1865. His unit fought at Petersburg, Virginia, from July 1964 to December 1864. This included the infamous Battle of the Crater, a battle that involved large numbers of Black troops and a massive amount of carnage.

Eli returned to Rocky Hill after the war and lived out his life as a farm laborer. He died on August 8, 1891, leaving his daughters, Clarissa A. Porter of Rocky Hill and Abigail Rodman of Wethersfield, behind. His estate was valued at $1,600 (approximately $46,000 in 2021), a significant sum for someone in his occupation. Eli Rodman's gravestone reads:

Eli Rodman
Co. G, 29th Reg. Conn. Vol.
Died Aug. 9, 1891
Aged about 65 Years

In September 1891, a will purporting to be Eli Rodman's, dated September 6, 1889, was filed with the probate court by Attorney Sidney E. Clark of Hartford on behalf of William Bulkeley and Samuel M. Dean of Rocky Hill and the Hartford Orphan Asylum. William Bulkeley seems to

have been a carpenter or house joiner; Samuel M. Dean was a blacksmith. The will reads, in part:

> *After all bills outstanding against me have been fully paid and settled, I direct that the remaining portion of my estate shall be divided in three equal parts. One of these or one-third of the whole I give, devise and bequeath to William A. Bulkeley of said town of Rocky Hill, to him and his heirs forever. One of these parts or one-third of the whole, I give devise and bequeath to Samuel M. Dean of said Rocky Hill, to him and his heirs forever.*
>
> *The foregoing bequests are given because of my appreciation of Mr. Bulkeley and Mr. Dean in helping and assisting me to obtain the property of which I expect to die possessed, and also for the many little favors they have done me in many other ways.*
>
> *The remaining one-third part of the whole of my estate I give, devise and bequeath to the trustees of the Hartford Orphan Asylum to them and their successors forever to be used by them at their discretion and according to their best judgement for and toward the maintenance of said asylum or some department of the same.*
>
> *Lastly, I nominate, constitute and appoint Sidney E. Clark of the Town of Hartford executor of this my last will and testament, and I direct and order that he shall not be required to give bond or furnish surety for the faithful discharge of said office.*

If you weren't a skeptical person, your first impression might be, "How nice of Eli to reward his friends and remember the orphanage." On a second reading, you might ask, "What about Eli's daughters? He left them nothing?" The daughters seem to have been unsophisticated in legal matters. Abigail signed her documents with an "X," indicating that she was illiterate, but just because she was illiterate does not mean she was stupid. She approached Rufus W. Griswold, the respected town doctor and historian, to be the administrator of the estate. Disturbingly, this will was originally accepted. It was only through the good offices of Dr. Griswold that this was reversed, and Eli's daughters got their inheritance.

A cynical person might view these facts and suspect that dirty dealings were afoot. Were the submitters of the original will deprived of their reward for "helping and assisting me [Rodman] to obtain the property of which I expect to die possessed, and also for the many little favors they have done me in many other ways?" A cynic might say that including the orphanage

doesn't pass the giggle test and seems to be a ploy to add credibility and sentiment to a shaky story. Did charlatans see an opportunity to acquire a sizable amount of money at the expense of two vulnerable Black women?

The 1890s weren't a good time for justice for Black people. It is fortunate that the women had Dr. Griswold to go to bat for them. As you read some of Dr. Griswold's writings, you may find some of his comments on race cringe-worthy by today's standards. Consider that he was a person of his time. When called to act on behalf of justice and to preserve the rights of these women, he was up to the task. The bogus will was disallowed, and the two women were declared Eli's heirs.

If you want to pay your respects to Private Rodman, you can go the Rocky Hill Center Cemetery. Start at the flagpole and walk east, to the Robbins crypt. Eli's grave is up the hill, to the southwest.

A Really Grand Old Flag

In March 2017, Lisa Zerio, director of Parks and Recreation, contacted the Rocky Hill Historical Society about an old flag that had been stored at the Rocky Hill Department of Parks and Recreation for many years. The society expected another forty-eight-star flag to add to its collection, but what it found was a real treasure. The flag is vintage from the Civil War. It has thirty-four stars arranged in a star pattern and measures thirty by twenty feet. The stars on the flag represent the states listed below. The southern states are represented because the United States never recognized their secession from the Union as legitimate.

Delaware, December 7, 1787
Pennsylvania, December 12, 1787
New Jersey, December 18, 1787
Georgia, January 2, 1788
Connecticut, January 9, 1788
Massachusetts, February 6, 1788
Maryland, April 28, 1788
South Carolina, May 23, 1788
New Hampshire, June 21, 1788
Virginia, June 25, 1788
New York, July 26, 1788
North Carolina, November 21, 1789
Rhode Island, May 29, 1790

Vermont, March 4, 1791
Kentucky, June 1, 1792
Tennessee, June 1, 1796
Ohio, March 1, 1803
Louisiana, April 30, 1812
Indiana, December 11, 1816
Mississippi, December 10, 1817
Illinois, December 3, 1818
Alabama, December 14, 1819
Maine, March 15, 1820
Missouri, August 10, 1821
Arkansas, June 15, 1836
Michigan, January 26, 1837

Florida, March 3, 1845
Texas, December 29, 1845
Iowa, December 28, 1846
Wisconsin, May 29, 1848

California, September 9, 1850
Minnesota, May 11, 1858
Oregon, February 14, 1859
Kansas, January 29, 1861

The following states joined the Union after this flag was made:

West Virginia, June 20, 1863
Nevada, October 31, 1864
Nebraska, March 1, 1867
Colorado, August 1, 1876
North Dakota, November 2, 1889
South Dakota, November 2, 1889
Montana, November 8, 1889
Washington, November 11, 1889

Idaho, July 3, 1890
Wyoming, July 10, 1890
Utah, January 4, 1896
Oklahoma, November 16, 1907
New Mexico, January 6, 1912
Arizona, February 14, 1912
Alaska, January 3, 1959
Hawaii, August 21, 1959

If you research thirty-four-star flags, you'll find several different star configurations, but the configuration found on this flag seems very rare.

Research shows that A.G. Parker raised $70 for the flag in 1861. This translates to about $1,600 in 2021. A.G. Parker was the postmaster of Rocky Hill at the time. The flag was originally made for another town but was never claimed. A.G. Parker may have purchased this flag as an act of patriotism in the early days of the Civil War. It may have also been an act of goodwill and intended to build his credibility in the town. He was recently appointed as postmaster and had replaced Henry Webb. The role of postmaster was under a cloud at the time. A *Hartford Courant* article reported that, during Webb's tenure, "many letters have been missed, it appears, and others received minus there valuable contents." It went on, "Webb, probably fearing arrest…suddenly left for parts unknown."

The flag was flown on a one-hundred-foot-tall flagpole that was especially built to hold it, and it was erected on the triangle on the south side of the Congregational church. It flew daily at this site for ten years after the end of the Civil War until the flagpole was struck by lightning and destroyed. Parker took custody of the flag, and when he died, Benjamin Smith, a prosperous farmer, took charge of it. Smith's daughter Adeline Wright then took it. She gave it to the Order of American United Mechanics, a popular lodge at the time, and when this group ceased to exist, the Griswold family took the flag. They ultimately gave the flag to the town clerk around 1931. It had been stored in that office ever since. For many years, the flag was displayed at

Thirty-four-star flag. *Author's collection.*

patriotic events, usually by draping, since it was too old and worn to fly, but it eventually became too dilapidated and fragile to even drape.

We know that a Griswold family took custody of the flag, but there are conflicting reports about which Griswold family is being referenced. A 1912 article in the *Hartford Courant* says that R.W. Griswold (apparently Roger Griswold, a doctor and historian and Rufus Griswold's son) took custody of the flag. A 1931 article says the flag went to William S. Griswold, a proprietor of Sunnycrest Farm. According to the 1931 article, Mrs. Griswold (apparently William Griswold's wife, Margaret) wrote a history of the flag, although we have yet to find this document.

The historical society would like to document, preserve and truly appreciate this piece of the town's history. It is currently wrapped in a bedsheet on a rack on the second floor of the Academy Hall Museum.

THE MAN WHO STOLE THE FERRY

The following is an excerpt from a book about the Rocky Hill–Glastonbury Ferry that is currently under review. The author owes much to the Glastonbury Historical Society for providing access to their research materials.

For the first two hundred years of its existence (circa 1650 to 1860), the Rocky Hill–Glastonbury Ferry was operated by the heirs of Joseph Smith, a recipient of one of the original land grants on the Rocky Hill Riverfront. In 1860, control of the ferry crossed the river to South Glastonbury, when the ferry and the privilege of operating it were sold to James Killam, a South Glastonbury toolmaker.

Killam deeded his rights to the ferry to his son-in-law Edward S. Boynton in the mid- to late 1860s. In 1863, Boynton was listed in the crew of the United States Navy's steam gunboat *Winona*. An 1864 article in the *Hartford Courant* reported that the ferry was sometimes unavailable when passengers needed it and that "someone should be censured." Boynton was the ferry's operator, and his service as a ferryman seems to have been erratic at a time when the ferry was essential. South Glastonbury businesses, notably a munitions factory that served the Union army, relied on the ferry to procure raw materials and reach their markets. In 1865, the towns of Rocky Hill and Glastonbury sought an injunction from the Connecticut Supreme Court to prohibit Boynton from suspending service or absconding with the ferry and ordered him to operate the ferry in accordance with state regulations. Boynton ignored the court's prohibition, abandoned the ferry privilege and

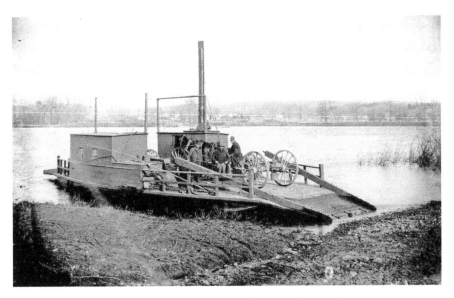

Steam ferry, circa the 1860s–1870s. *Courtesy of the Glastonbury Historical Society.*

left the area. He didn't abandon the ferry boat, however; he took it with him, leaving the towns without a boat.

There is a question of whether the first steam-driven ferry began its service in 1860 or 1866. The circumstances of Boynton's departure point to 1860. During this period, the means of locomotion for the ferry was transitioning from horses on a treadmill to steam power. It seems likely that the ferry Boynton took was a steamboat, since it's hard to imagine absconding down the river on a boat driven by a horse (or horses) on a treadmill. A lot of silage would have to have been stored, and waste disposal from the horses would have been a problem. Since Boynton was violating a court order, he would have needed to move quickly. A horse on a treadmill probably wouldn't have sailed down the river fast enough to facilitate a hasty retreat. A steamboat, however, would have done the trick. More research needs to be done on this.

The advent of steam power forced changes in the skill sets of ferrymen. It was no longer enough to have the physical strength to pole or row a boat and to have local knowledge of the small stretch of river between the Glastonbury and Rocky Hill landings. A new type of crewman, an engineer, was required to manage the stream engine. In the 1860 U.S. census, James Killam was listed as a toolmaker, which argues that he had mechanical skills. He also built at least one steam ferry. Edward Boynton's occupation was listed as engineer, which qualified him to operate a steam engine. In later

years, ferrymen were most often experienced sailors, familiar with nautical machinery rather than local people.

With Boynton and the ferry gone, the towns of Rocky Hill and Glastonbury had to scramble. The two towns cooperated to put a flatboat, apparently propelled by oars or poles, in as a stopgap measure, and it ran for a time at a loss to the towns. Rocky Hill and Glastonbury held a joint town meeting to address the situation, and James Killam returned to operate the ferry. The towns clearly wanted stable, orderly operation of the ferry and drafted the following agreement with Killam:

> *Know all men by these presents, that I, J. Layman Killam of the town of Glastonbury in County of Hartford and State of Connecticut, am holden and firmly bound for myself and my heirs and assigns unto the town of Glastonbury and Rocky Hill in said county and their assigns in the sum of one thousand dollars, to which payment well and truly be made and done, I bind myself and my heirs, executors and administrators firmly by these presents: signed with my hand and sealed with my seal and dated this 16th day of August AD 1866.*
>
> *The condition of this obligation is such that whereas I the said J. Layman Killam have constructed a steam ferry boat properly equipped with and have the same in operation at the old site of the "Rocky Hill Ferry" and have also agreed for myself and my heirs and assigns to run or cause to be run said ferry boat or one similar thereto across said river at said ferrying place at all times and seasons whenever practical and as the usual course of public travel shall require for the term of ten years from and after the tenth day of April AD 1866 and fully to be complete and ended on the tenth day of April AD 1876. And so as to secure and save the towns foresaid harmless from any and all expenses for running and keeping in operation said ferry as they by law are obliged to do, and also have agreed and build the necessary landings on both sides of the said ferrying place and to keep the same in repair for the term aforesaid, and also I keep the said ferry boat fully insured for said term, and the policy assigned to said towns as security for the full performance of the covenants aforesaid: now if I shall well and truly keep, perform, and abide by the covenants herein contained, then this shall be void. Otherwise be and remain in full force.*
>
> *Dated at Glastonbury, this 16th day of August AD 1866*
> *In presence of*
> *William S. Goslee*
> *J.L. Killam*
> *William Holden*

The name of the ferry (or ferries) that Killam introduced is apparently lost to antiquity. The first steam ferry we can name was the *Centennial*, built in 1876, the United States' centennial year, by Killam.

The towns probably breathed a heavy sigh of relief that, with resolution of the Boynton issue, the problems with the ferry were finally resolved. Little did they know what lay ahead in 1888, when Martin T. Hollister was embroiled in a feud with the towns of Rocky Hill and Glastonbury over the right to operate the ferry. Boynton turned up like a bad penny and sold his dubious rights to the ferry he had abandoned twenty years earlier to Hollister.

WHY THE STATE TOOK OVER
THE FERRY

The following is an excerpt from a book about the Rocky Hill–Glastonbury Ferry that is currently under review. The author owes much to the Glastonbury Historical Society for providing access to their research materials.

The ownership of the ferry has been vague from its beginning. Its first mention is in a legal document from 1724, when the general court granted Jonathan Smith "the liberty" of the ferry. What did this mean? What did "the liberty" entail? The enabling documents didn't provide much detail. Consequently, the legal meaning had been subject to various interpretations based on conditions at different times. Jonathan Smith's "liberty" was passed on to his son-in-law Hezekiah Grimes by the general court in 1734. Later generations assumed they owned "the privilege" through inheritance. In later years, this "liberty" came to be called "the privilege" of the ferry, but this change in terminology didn't add much clarity. Certainly, the privilege was something less than a charter or franchise and never conferred the exclusive right to operate a ferry that a charter or franchise would have done. Disputes over this matter would ultimately have to be settled in court.

The issue of what "the liberty" or "the privilege" meant didn't come up in the early days of the ferry. It existed to serve farmers in South Glastonbury and to provide them access to the river port on the Rocky Hill side. It also gave them access to major thoroughfares, including the Post Road, later the Hartford–Saybrook Turnpike, on the west side of the Connecticut River.

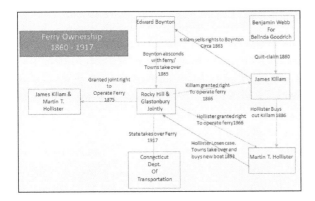

Ferry owners. *Author's collection.*

The Smith-Grimes family controlled most of the landing spots on the Rocky Hill side of the river, so competition wasn't an issue. As the Rocky Hill river port's importance decreased and industry grew in South Glastonbury, the ferry became an essential factor in South Glastonbury's economic well-being, and by 1860, its control had crossed the river to South Glastonbury.

During the 1840s and 1850s, several quitclaim agreements were executed for the ferry, either to transfer rights or secure mortgages. The things that were being transferred or mortgaged were "the ferry" and the physical property (boats, horses, appurtenances, land, et cetera) associated with the ferry. In most of these transactions, "the ferry" apparently meant "the privilege." It was transferred or mortgaged as a separate item from the physical ferry.

Benjamin G. Webb of Rocky Hill quitclaimed the "privilege" of the ferry to James Killam of South Glastonbury in 1860, and Killam passed it on to his son-in-law Edward Boynton. Until Boynton absconded with the ferry in 1865, the towns of Rocky Hill and Glastonbury were content to let private interests operate the ferry. When Boynton abandoned operations and left, taking the ferry with him, the towns faced a crisis. A main transportation and communications artery was severed during a national crisis, the Civil War. Something had to be done. The towns contracted with James Killam and, later, Martin T. Hollister to build and operate steam ferries, but questions remained. Did the old assumptions still apply? Had the towns taken over the "privilege," and if they had, did they then have the legal right to do so? What was owned? The "privilege," the physical ferry or both?

In February 1886, Martin T. Hollister was the winner of a competitive bid for the operation of the ferry and contracted with the towns of Rocky Hill and Glastonbury jointly. He agreed to pay each town $20 a year for ten years, a total of $40 per year. Adjusted for inflation, this would translate to $1,098 a year in 2021 or $10,980 over ten years for the right to operate the ferry

and collect tolls. Hollister bought out all of James Killam's interest in the physical ferry and became its sole operator. A written agreement was signed by Hollister and the selectmen of the two towns. The selectmen understood this to be an indenture and an agreement of the lease of the privilege. It was signed and sealed by all parties. Hollister had the eponymously named steam ferry *Hollister* built and put into service in 1888.

Hollister ran the ferry and collected tolls for two years but failed to pay the towns their fees. The towns brought forward a suit. Whether this was done as a legal maneuver or to rub salt into old wounds, Hollister arranged with the absconded Edward Boynton to quitclaim all his rights in the ferry to him. Since Boynton was the last private citizen to claim the ambiguous "privilege," Hollister seems to have planned to use this to assert his claim to the ferry over that of the two towns.

In 1893, Hollister petitioned the legislature for a fare increase, which was resoundingly refused. According to an article in the March 6, 1893 edition of the *Hartford Courant*, the defeat "meets with the approval of nearly everyone here, on both sides of the river. People very naturally object to additional ferry taxation to enable Mr. Hollister to keep on his fight against meeting the terms of his contract as to the use of the privilege." It seems that it was Hollister against everyone, but he didn't seem in any way deterred by this.

The case dragged on through the courts from 1888 to 1890. In 1890, the court ruled that since the "privilege" had been abandoned in 1865 and the towns had been legally obliged to take over the operation of the ferry, they then held "the privilege." Moreover, the towns had the obligation to either operate the ferry or contract to have the ferry run. Hollister was to pay his fees and continue to operate the ferry for the term of his contract. Hollister tried several ploys—too numerous to detail here—to keep control of the ferry and avoid paying his fees, but they were all in vain.

After the legal battle with Martin T. Hollister was settled, the towns of Glastonbury and Rocky Hill took joint ownership of both the "privilege" and the physical ferry, putting the steam ferry *Rocky Hill* into service in 1894.

After the towns contracted with a series of less-than-adequate operators and had to replace the inadequate *Rocky Hill* with the more suitable ferry, the *Nayaug*, Connecticut's congress lost its patience. At this time, the ferry was still an important part of the state's highway infrastructure. By an act approved by the Senate and House of Representatives, to be effective October 1, 1917, the State of Connecticut took over operation of the ferry.

There are signs at both ferry landings that say: "This ferry became a state facility in 1915." The research of Ellen Rafferty, a South Glastonbury

Ferry historical marker. *Author's collection.*

historian, contains the act by which the state took over the ferry on October 1, 1917. She also shows that the Town of Glastonbury was collecting receipts from the ferry from 1915 to 1917. A March 5, 1917 *Hartford Courant* article confirms that control of the ferry was turned over to the state in 1917. The statement that the ferry began operation in 1655 also bears scrutiny. It's hard to pin down a date for the start of the ferry. Popular guesses are 1650 and 1655, but the ferry seems older than this.

ICE FARMS

In our age of refrigeration, it is hard to remember that the ice industry once played a significant part in Rocky Hill's economy. Ice farms dotted the New England landscape in the nineteenth and early twentieth centuries, including Charter Pond in Rocky Hill and Wethersfield, which was owned by the Spring Brook Ice Company. You can get an appreciation for the size of this expanse by searching online and finding Goffe Brook. The Spring Brook Ice Farm, also called Charter Pond, followed Goffe Brook. Its southern terminus was the Goffe Brook Dam, just short of the I-91 underpass on the west side of Old Main Street in Rocky Hill. The ruins of this dam still exist. The northern terminus was where Millwoods Park is located in Wethersfield today. Charter Pond and modern-day Charter Road in Wethersfield were named for George D. Charter, the superintendent of the Spring Brook Ice Company who died in 1893. There was another ice farm along Dividend Brook in the southern part of town.

Ice farmers prided themselves on the clarity and purity of their ice and took great pains to prevent bubbles and impurities.

Frederick Tudor of Boston developed methods for storing ice and preventing it from melting in the early nineteenth century. This was primarily done by keeping it out of the sun, burying it where possible and covering it with sawdust. The first use for this new technology was to provide ice for domestic use. Most households in America, including those in Rocky Hill, had an ice box, the precursor of the refrigerator. An iceman would deliver large blocks of ice at regular intervals to homes for use in their ice boxes. In

Ice dam on Old Main Street. *Author's collection.*

spite of insulation, the ice would melt, and a daily household chore was to empty the drip tray.

It wasn't long after Tudor's discovery that ice could be stored that enterprising Yankees realized that they could combine these technologies with their maritime culture to ship ice to the southern states and the Caribbean, both for consumption and as a primitive form of air conditioning.

At its peak, the ice industry was crucial to private homes and businesses. Many people bought their ice from ice companies, although some farms maintained their own private ice farms. The Spring Brook Ice Company was the main ice provider in Rocky Hill.

The importance of the ice industry had dramatic results. The Ice Combine, a consortium of ice producers, was a monopoly that drove small providers out of business and controlled the supply of this crucial resource. During the Gilded Age, this industry was akin to the monopoly of railroads, oil and other essential industries, except this monopoly affected the kitchens in every household. The Ice Combine controlled the supply and price of ice in spite of a hue and cry from the public and legal actions by the state to it break up. The combine's grip was only broken with the introduction of refrigeration at the beginning of the twentieth century.

Its perishable nature made ice vulnerable to criminals, street gangs and organizations like the Black Hand. Ice melts over time, so delaying delivery

is an effective means of extortion. It was no coincidence that the ice pick was a favored weapon among early twentieth-century criminals. Some remnants of this still exist. You may remember in the film *Goodfellas* that Tommy killed Morrie by driving an ice pick into the base of his skull. The ice pick made a small, deep puncture that could reach a vital organ and cause an infection that was very hard to treat.

Refrigeration technology arrived in the early twentieth century. The first use of this technology was to create plants where ice could be produced without the intervention of Mother Nature. This freed ice producers from reliance on the weather and undermined the control of the combine and the criminals.

The ice industry lasted into the 1930s, when households acquired electricity. Freon made refrigeration possible, and electricity drove the machinery to make it work. Refrigerators replaced ice boxes, and reefer technology replaced the old methods of transporting and storing ice and perishable products.

Many ice companies still exist. Spring Brook Ice Company still operates in New Britain, Connecticut, selling ice and heating oil.

THE FOUNDRY

The foundry site in Rocky Hill was located on the riverside to capitalize on shipping advantages. The river provided an efficient means of carrying coal and raw materials to the foundry, as well as shipping finished products. Two wharves, the Coal Dock on the north end of the foundry and the Lower Dock on the south end, allowed for the loading and unloading of raw materials and finished products. The arrival of the railroad in 1872 and the construction of the Silas Deane Highway and, later, Interstate 91 enabled truck drivers to bring raw materials and coal to the foundry and distribute its products all over the country. There was a downside, however. The pollution of the area's water and air was an ongoing problem.

In the early years, the northern two-thirds of the foundry property belonged to the Grimes and related families, as did most of the land on the northern riverfront. Several businesses occupied this space. William Neff and Edward Merriam ran a carriage shop here starting in 1835. This property began its history as a manufacturing center with the Rocky Hill Manufacturing Company in 1849. It made cast iron goods. This enterprise failed in 1853. For several years, the site served as a carpentry shop and a distillery that manufactured vinegar and champagne cider. The site later held a boardinghouse for workers on the new railroad. The boardinghouse burned down in 1876.

A sea captain named Jacob Brandagee owned the southern one-third of the site until he died at sea in 1765. William Webb, a sea captain and trader, owned this property in 1843. Justus Candee owned the property when it burned down at the same time as the boardinghouse in 1876.

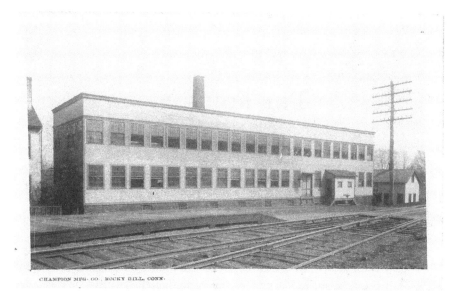

Foster-Merriam Foundry. *Courtesy of the Rocky Hill Historical Society.*

In 1881, a consortium formed a private subscription company that purchased the two parcels of land and built a foundry there. The foundry was sold to A.D. Heart and Company, which failed after eighteen months. Ownership of the land reverted to the original subscribers. The plant remained idle until 1884, when the subscribers organized a new company as the Pierce Hardware Company, which became insolvent in 1888.

Not surprisingly, fire has always been a threat at this heat-based, coal-fired facility. There was a fire in 1890 at the Maltbie and Hanley Foundry, which occupied the facility after Pierce failed. It doesn't seem like the fire destroyed the building, and Champion Manufacturing Company procured the facility around 1890. Champion occupied the foundry until 1916, although it leased the foundry to several other companies. It seems Austin Manufacturing occupied the building in 1914 to make vending machines, although it is unclear if Austin ever occupied the building. In 1916, Foster-Merriam leased the site. In April 1918, a spark from the foundry set the Yeager Store and residence at 205 Meadow Road on fire. But the fire was brought under control with only minor damage.

The Foster-Merriam Foundry occupied the site when it caught fire and burned to the ground on Christmas Eve in 1918. The building was owned by the principals of Champion Manufacturing Company, Frank E. Holmes

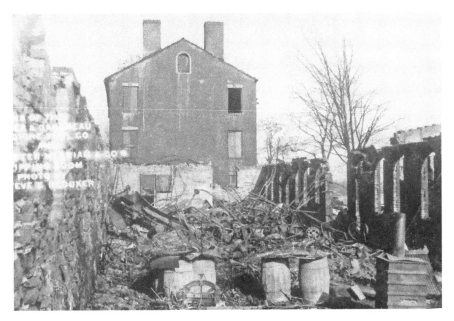

Foundry fire. *Courtesy of the Rocky Hill Historical Society.*

and Edward J. Stevens, who sold the property to the Connecticut Foundry Company. This company built a modern foundry, which operated there successfully for sixty-five years.

All was peaceful until 1977, when the Lady's Garment Workers Union won an election and tried to unionize the foundry. A protracted strike ensued. Nonunion workers tried to break the strike, and union picketers harassed employees and set fire to cars and homes. In one case, they shot and wounded a worker who was operating a carpool. They also blocked traffic and vandalized vehicles.

The strike dragged on for several years, as the union was certified, but the foundry management refused to recognize it. In 1983, the foundry permanently closed its doors, unable to remain viable in the face of labor unrest and the expense involved in addressing its pollution issues.

The foundry property has been idle since 1983, suffering the effects of time. The buildings and water tower gradually deteriorated and were razed. The ownership of the property has changed hands several times, as plans for redevelopment have fallen through.

In 2011, a development agreement was reached between the town council and Riverfront Future Partners that promised to transform the abandoned foundry eyesore into a mixed-use showpiece: a complex of seventy-eight

School bus vandalized during foundry strike. *Courtesy of the Rocky Hill Historical Society.*

upscale condominiums; offices and shops; a restaurant; a public park dedicated to former state representative Richard D. Tulisano; and a scenic pedestrian walkway along the river bluff.

This plan has suffered setbacks. The most difficult of these seems to be that the developer must reach an agreement with the Providence-Worcester Railroad to allow for changes to be made to the state-owned railway bed where it crosses Glastonbury Avenue. You may have heard the train whistles. The railroad has started to use these tracks again on a limited basis. This will surely impact development plans.

ROCKY HILL'S COUNTRY DOCTORS

There was a time when, if you had a health crisis, a beloved country doctor would hitch up old Dobbin to the sleigh, come to your house (perhaps during a blizzard) and provide medical care in your home. Today, you have to wade through a complex morass of concepts and terminology to be sure you've done everything correctly to protect your health. The ball is in your court to acquire healthcare—matching insurance to your personal situation, defining open enrollment periods, finding a primary care provider who is willing to take you on, in-network versus out-of-network. Understanding Medicare, parts A, B, C and D and all their permutations falls to you. When you figure it all out, will the government change (and probably complicate) the rules? The quality of medical care is constantly improving—as is its complexity.

In its early history, medical practice was more of a trade than a profession. Medical skills were often passed down from father to son and sometimes son-in-law. The Connecticut Medical Society was formed in 1792 to establish standards and bring some professionalism to the trade. The Yale School of Medicine opened in 1813, and the practice of medicine grew and improved throughout the nineteenth century.

Baby Deming was the first person to be buried at Center Cemetery (1731). She died at birth and wasn't given a name. We don't know the cause of her death. Infant deaths were commonplace in the eighteenth century, but they were surely no less heartbreaking. Baby Deming's parents were Benjamin and Mary Deming. The Deming house still exists at 1 Pratt Street,

at the corner of Pratt Street and Dividend Road. The Demings buried their daughter in the new cemetery, where they could look out the window and see her grave. Her gravestone reads:

Here lies the
body of the daughter
of Benjamin and
Mary Deming born
and died June ye 12
1731 the first buried
in this yard

Childbirth was also a dangerous thing for much of our history. Woman often died during childbirth, and it was typical for a family to have as many as ten children—two or three of whom died before the age of ten. There was no permanent doctor in Rocky Hill until 1774. The nearest doctor was in Wethersfield, and they were unlikely to travel on horseback on the primitive, muddy roads for something as commonplace as a childbirth. Medical care typically involved having a book such as *English Physician, Every Man His Own Physician* or *Domestic Physician* that contained a few primitive procedures and treatments in the house. If you were lucky, there might be a midwife or bonesetter available.

According to Dr. Rufus Griswold's writings, medical support came to Rocky Hill with the first full-time doctor, Aaron Horsford. For about two

hundred years, beginning with Horsford's practice, doctors lived in the center of town and practiced out of their homes, where they were easily accessible. They would make house calls in emergency cases. Dr. Horsford lived at 660 Old Main Street and practiced there from 1774 to 1804, with a break to serve in the Revolutionary War. Dr. Horsford was an improvement over the time of do-it-yourself books, midwives and bonesetters, but his cures might have still involved bloodletting, bee stings, leeches and extremes of heat and cold.

It seems Joseph Higgins served concurrently with Doctor Horsford, starting in 1788, and he was one of the early members of the Connecticut

Dr. Oran Moser. *Courtesy of the Rocky Hill Historical Society.*

Medical Society. He was one of the many doctors who succumbed to the disease he was committed to fighting: he died of consumption (tuberculosis) in 1797.

Dr. Horsford and Dr. Higgins were succeeded by Dr. Daniel Fuller, who practiced in Rocky Hill from 1804 until his death in 1843. Yale Medical School opened in 1813, and Dr. Fuller received a degree from there. He practiced at 3 Riverview Road (as did several other doctors). He was also a teacher of music—the Rocky Hill Congregational Church treasurer's books show payments to him at various times, from 1805 to 1816, for "teaching music and leading the choir."

The American Medical Association was founded in 1843, and Sylvester Bulkeley, who received a medical degree from Dartmouth College and practiced in Rocky Hill from 1848 to 1857, was a member. Things had come a long way from midwives and bonesetters; there were licensed physicians with medical degrees and certifications from professional organizations.

Ashbel W. Barrows practiced medicine in Rocky Hill for a brief time, from 1841 until 1848, when he removed to Hartford and established a state and national reputation. He, too, practiced at 3 Riverview Road. He testified as an expert witness at the trail of Henry Wirz, the commandant of Andersonville Prison, where several Civil War soldiers from Rocky Hill had perished.

Wait R. Griswold was born in Wethersfield in 1820 and came to Rocky Hill late in life, at the age of fifty-one. He practiced medicine here from 1880 to 1887. He graduated from Yale in 1844 and received his MD from Columbia University Medical School. He had served as second assistant surgeon with the Eighty-Sixth Regiment of Colored Infantry during the Civil War. He left his practice to enter the questionable patent medicine business and also served as a Connecticut state representative.

Rufus W. Griswold practiced in Rocky Hill from 1854 until his death in 1902. In addition to his medical practice, he served as a town historian. Most of the information in the Rocky Hill section of *History of Ancient Wethersfield* was derived from his notes.

Frank R. Burr practiced in Rocky Hill from 1884 to 1918 from his home at 557 Old Main Street. The Rocky Hill Historical Society has several artifacts from him in its collection, including Dr. Burr's medical bag and tool bag.

By the time Oran Moser arrived in Rocky Hill in 1903, medicine had become the disciplined profession we are now accustomed to. His son David inherited his practice. There is much to say about the two Drs. Moser. *Beloved* is not too strong a word to describe these men. The two Drs. Moser were

the last traditional country doctors in Rocky Hill. That is, they were doctors who were deeply involved in town affairs, made house calls and knew their clients intimately. Both practiced from their family home at 18 Elm Street. Oran Moser served the town from 1903 until his death in 1953. His son served from the time he was discharged from the U.S. Army Medical Corps in 1945 until 2002, and he was also the first mayor of Rocky Hill when the town's government changed from selectmen to a mayor, manager and town council form of government. The Rocky Hill Historical Society has several artifacts that commemorate the two Drs. Moser.

When Interstate 91 was built, the population of Rocky Hill ballooned. Today, there are many doctors, and people often travel out of town for medical attention. The intimate relationships between country doctors and their patients are things of the past.

THE TWO DRS. MOSER

The Rocky Hill Historical Society posted an article about country doctors on October 29, 2020. People responded with an outpouring of fond memories of the two Drs. Moser. In 2017, the Rocky Hill Historical Society held a tribute to them to coincide with the replacement of the old Moser School. It included a PowerPoint presentation and a paper covering the history of the Mosers in detail.

The two Drs. Moser made substantial contributions to Rocky Hill. Moser School is named for the two doctors. Moser Drive is named for Oran Moser, a beloved country doctor who died in 1953. His son David was also a country doctor and the town's first mayor. We shouldn't let time obscure the debt of gratitude we owe to these two men.

Dr. Oran Moser was born in Patterson, Iowa, on July 1, 1871. He spent much of his childhood working for a man named David Woods on a farm in Kansas. He aspired to be a doctor and moved to Beatrice, Nebraska, where he had worked as a nurse while finishing high school. The doctor who employed him in Beatrice got a position in Waterbury, Connecticut, and invited Dr. Moser to accompany him there. When his benefactor moved on to another position, Oran was left to decide what to do with his life. David Wood, who had employed Moser when he was a boy, offered to pay his tuition for medical school if he could pay his own living expenses. Dr. Moser applied and was accepted at Yale Medical School. He graduated from there in 1902. Upon graduation, he served as a physician at the Wethersfield State Prison. He came to Rocky Hill and set up a practice in 1903.

Dr. Moser was known for making house calls at all hours and in all kinds of weather: on horseback, on a bicycle, later by automobile and sometimes on snowshoes. One can imagine Dr. Moser getting a call on his old-timey hand-crank phone, getting on a bicycle or in a horse-drawn sleigh, getting as close to the patient's home as he could and then strapping on his snowshoes to complete his mission. Dr. Moser's legendary snowshoes are kept in the Rocky Hill Historical Society's collections.

Dr. David Moser. *Courtesy of the Rocky Hill Historical Society.*

Dr. Moser delivered 920 babies in Rocky Hill and Wethersfield between 1902 and 1952. During World War I, Dr. Moser was the examining physician for the Hartford County draft boards, where he was charged with evaluating draftees' physical fitness for duty as well as appeals for exemption from the draft. Dr. Moser served in the same role in World War II.

Dr. Moser had one of his many fine moments during the Spanish influenza epidemic, which lasted from 1918 to 1921. Dr. Oran Moser's service was heroic during this plague. In 1918, he was quoted in a *Hartford Courant* article as reporting that the influenza was not widespread in Rocky Hill. Two days earlier, his first wife, Lottie (Kierstead) Moser, had died of influenza. One has to wonder if he suppressed his grief and issued this statement to avert panic over the influenza threat. In January 1919, Dr. Moser contracted influenza himself, probably from exposure in the course of doing his job. Fortunately for Rocky Hill, he recovered. From October 1918 until July 1920, when he married Nellie McPherson, Dr. Moser was the single parent of his son David, who was born in August 1918.

Had Dr. Moser served the town as a simple country doctor, he would have more than earned our respect and gratitude. Dr. Moser was also the primary physician at what was to become the Connecticut Veterans' Home in Rocky Hill from 1932 to 1940. A story that is told by old-timers attests to Dr. Moser's character and commitment to his calling. For a long time, there has been a liquor store on Main Street, down the hill from Dr. Moser's house at 18 Elm Street. Men from the veterans' home would walk down to the store to buy liquor. According to the story, Dr. Moser set up a picnic table where the veterans could sit and drink. He established rapport with these men and gained their trust so he could talk to them in a non-preachy way about the

damage alcohol abuse did to their bodies. He was sometimes known to buy liquor for someone who had no money in order to reinforce that he was not moralizing. He could then address the threat to the man's health.

While he was providing medical services at the veterans' home, he invented a portable, sanitary water dispenser to combat an outbreak of trench mouth during a construction project there.

He also did much more. On September 1, 1918, he was appointed health officer and medical examiner of Rocky Hill, and he held that post until October 6, 1952. From 1921 to 1923, he served Rocky Hill in the state legislature. He was the president of the Hartford County Medical Society in 1933. He also served as the vice-president and director of Cromwell Savings Bank. He was active in the Rocky Hill Congregational Church, where he served as a trustee.

South School in the south end of Rocky Hill was renamed Dr. Oran A. Moser School to honor Dr. Moser in 1947. He never really retired, and he died, still serving the community, on November 10, 1953.

David Woods Moser was Oran Moser's son. He was named for the Kansas farmer who had employed his father and been kind to him thirty-seven years earlier. David followed in his father's footsteps and carried on his father's tradition as a country doctor and public servant. David received a bachelor's degree from Bates College in Maine, went on to get a master's degree from Trinity College in Hartford and then went on to get his medical degree from Tufts Medical School in Medford, Massachusetts. Dr. Moser served in the United States Army Medical Corps during World War II.

Dr. Moser practiced out of the same home office his dad had used at 18 Elm Street in Rocky Hill. Like his father, he prided himself on being available and would see patients on a first come, first served basis, rather than by appointment. He made house calls when summoned. He was known to be blunt and outspoken but honest. He wasn't afraid of controversy and began vaccinating the town's children for polio when this was a controversial treatment. By so doing, he probably saved the health and lives of many Rocky Hill children.

People tell stories of Dr. Dave, as Dr. Moser was also known, bringing M&M candies on house calls and giving them to children, calling them pills, while he played board games with them.

Like his father, David served the town above and beyond his work as a country doctor. David was the first mayor of Rocky Hill after the selectman form of government was replaced. He set the pattern for future mayors. He served three two-year terms, from 1967 to 1973. He also served as the

medical director of West Hill Convalescent Home on West Street in Rocky Hill, as the physician to the town's schools and as the health officer for the town's police and fire departments.

Oran Moser died on November 10, 1953, and David died on January 22, 2002. They were buried in a family plot at Center Cemetery. The Rocky Hill Historical Society conducts tours of the cemetery in the spring, and it recently developed a two-hour tour for adults in cooperation with the Central Connecticut Health District. The Moser family plot is one of the highlights of the tour.

ROCKY HILL IN WORLD WAR I

I n 2016, work began on the book *Rocky Hill in World War I*. There is a World War I memorial on Center Green (also known as the Rock), and it provided the key to discovering the people and their stories that bring that history to life. There are seventy-two names on this monument, although further research has uncovered many more veterans since then.

The names on the Rock were supplemented by a book titled *Service Records: Connecticut Men and Women in the Armed Forces of the United States during World War, 1917–1920* (available for free on www.archives.org). This book contained thumbnail sketches of each veteran and listed about twenty veterans whose names don't appear on the Rock. With a list of veterans developed, researchers began digging into town records, newspaper archives, genealogy records and all the other usual sources for historical research.

The result was the book *Rocky Hill in World War I*. This book is available through the Rocky Hill Historical Society:

Rocky Hill Historical Society
P.O. Box 185
Rocky Hill, CT 06070

This chapter hits the high points included in the book, but one can find many more interesting details there.

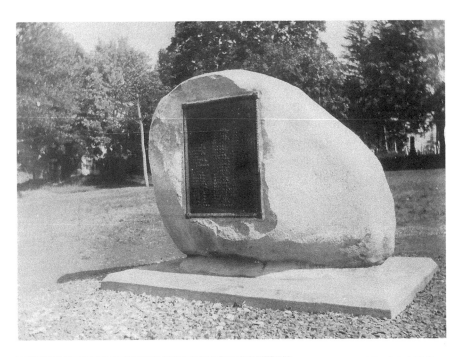

Above: Rocky Hill World War I monument. *Courtesy of the Rocky Hill Historical Society.*

Left: Rocky Hill World War I book cover. *Courtesy of the Rocky Hill Historical Society.*

To understand how people behaved in the war, you have to put yourself in their place and imagine the passion and frustration they felt as they contributed to the war effort in support of their loved ones. The war permeated everyone's reality, and everyone's patriotism was scrutinized and evaluated. Every organization—be it a church, the Grange, the Motherhood Club (which became the PTA) or the Rocky Hill Men's Club—sponsored patriotic efforts in support of the troops. Food production and conservation efforts became a central focus to ensure the troops were amply supplied. Participation in patriotic efforts was not optional. If you didn't participate enthusiastically, you might be classified as a "slacker." In extreme cases, you might be visited by a federal official.

Early in 1917, the Connecticut military census was created. Although the census appeared to be an inventory of Connecticut men available for military service, Governor Marcus Holcomb made it clear that it was intended to create an inventory of alien men, who were to be given special scrutiny. Men with German surnames were wise to enlist to avoid harassment.

Reminders of the war and inducements to patriotism were everywhere. The Rocky Hill Railroad Station was papered with war posters. Every waterfront in America, including the Connecticut River, was considered a "barred zone." A pass or other recognized means of identification was required to approach it. These passes were issued by the United States Marshal Service. Some passes were universal, providing access to an entire port; others were restricted to a particular place. You could be jailed for misusing a pass.

Some Rocky Hill residents made names for themselves at a state level. George B. Chandler had been Rocky Hill's representative to the general assembly and was the state compensation commissioner when the war broke out. In May 1917, he was made the chairman of the Council of Defense Committee of Publicity under the Committee of Public Information (CPI), which was, basically, an organ for generating propaganda in support of the war. His efforts were so successful that he was asked to tour the western United States, explaining the purpose of his committee and its activities. When he resigned at the end of the war, Chandler submitted a paper warning of the dangers of state-sponsored propaganda, except in times of extreme national peril.

Ruth Chandler was George Chandler's daughter. She served as publicity assistant under her father until she enlisted in the army and entered a nursing program at Camp Meade, Maryland, in August 1918. Ruth wrote several articles for the *Hartford Courant* from Camp Meade, providing

details about the soldiers stationed there. A woman named Ruth Chandler Moore wrote several articles for *Collier's Magazine* in the 1930s. Although it can't be confirmed that this was Rocky Hill's Ruth, she was a writer married to a man named Moore, and the timing is right for this to be the same person.

Reverend Morris Alling, the minister of the Rocky Hill Congregational Church, was in charge of the subcommittee of the Council of Defense Committee of Publicity under the Committee of Public Information (CPI), and he was charged with overseeing 350 to 440 Four Minute Men. These were prominent men in the state who delivered tightly scripted, highly controlled four-minute speeches in support of the war in theaters and movie houses before the shows and during intermissions. The Four Minute Men often spoke in support of Liberty bond drives, Red Cross campaigns, Americanization and other patriotic endeavors.

Frank W. Churchill was Rocky Hill's representative to the state legislature during the war. He was also active in town politics, serving on the Board of Relief, which dispensed town charity, and on the town school committee. He attended patriotic events, such as Memorial Day and Fourth of July ceremonies, as a representative of the state. He was a prosperous farmer in Rocky Hill. His wife served on the War Savings Committee, developing a canvassing list for the collection of contributions.

The only major sea battle in World War I was the Battle of Jutland, which occurred before the United States entered the war. The United States Navy's involvement was mainly against submarines and surface raiders. Walter Robbins, who served aboard the USS *Cassin*, had his ear drum ruptured during a torpedo attack.

There were three classifications of soldier in the U.S. Army during World War I. The national guard was intended for home defense, but it became the primary combat force when war broke out. Rock Hill men belonged to the acclaimed Yankee Division. It had served in the Mexican Expedition and was combat-ready when the United States entered World War I. Connecticut men served in the 102nd Regiment of the Yankee Division. The Yankee Division was scheduled to go to Alabama for training, but there were several influential businessmen in the division who used their contacts to arrange transportation and support that resulted in the Yankee Division going to Europe rather than Alabama. As a result, the Yankee Division were the first national guard troops committed to combat.

Some Rocky Hill men were in the Regular Army. This was made up of the standing army, which had existed before the draft, and men who enlisted

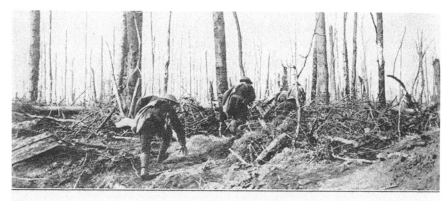

Advancing After St. Mihiel

Battle of St. Mihiel. Connecticut Fights: The Story of the 102nd Division, *book in the public domain.*

before they could be drafted. The Regular Army arrived in Europe shortly after the Yankee Division.

When the United States entered World War I, it was woefully ill-prepared. The army was small and not well trained. The Selective Service Act was passed by Congress on May 18, 1917, and resulted in the National Army, which was made up of draftees.

The Yankee Division arrived at Neufchateau in France, which was part of the Chemin de Dames sector. This area had previously been an active battle site but was fairly calm when the Americans arrived. There was a brief respite there while the American force was built up, but it was short-lived. The Germans attacked Chemin de Dames and began the Second Battle of the Marne. Angelo Campilio, Rocky Hill's only World War I soldier killed in combat, died there.

General Erich Ludendorff, the commander of the German army, ordered a massive offensive in the spring of 1918. American forces were assigned to St. Mihiel in the Toul sector to free up more experienced French troops to halt the German offensive near Paris. This was the first independent action fought by the Yankee Division. The St. Mihiel salient was a bulge of the German lines into Allied lines on high ground, with defenses cut into bedrock. It had been a thorn in the Allies' side throughout the war. The Americans were transported the several hundred miles from Chemin de Dames by train. The Germans launched massive attacks to test these untried American forces and, hopefully, break their spirit. The Americans remained salient and steadfast and acquitted themselves well.

The Battle of Muese-Argonne was the last battle of the war. It lasted one hundred days; 26,277 were killed, and 95,786 were wounded. It was the bloodiest battle in U.S. history.

A song that was popular after the war asked: "How you gonna keep 'em down on the farm after they've seen Paree?" In many cases, the answer was: "Sometimes you can, sometimes you can't." Some of the veterans who came home from World War I returned to their old lives; some found new occupations; and others moved away. The town changed and grew.

ELSIE RHODES

A Hero of Two Wars

For those of us who love Rocky Hill's history, the signs of our past are all around us. When you pass Terry Lane, do you every wonder, "Who was Terry?" "Why is Drum Hill Road called Drum Hill Road?" And so forth. The Rocky Hill Historical Society works hard to understand and preserve the signs of our past. It did this in campaigning to preserve the name Moser School to honor Drs. Oran and David Moser. Rhodes Road is a small road that runs west from Cromwell Avenue. It would be easy to overlook or rename if you didn't know anything about it. This was once the home of Rhodes Farm. Also, there is a World War I monument on Center Green that bears the name "E.G. Rhodes" among the names of our heroes. Pursuing these little nuggets has led to a fascinating story.

E.G. Rhodes was Elsie Gertrude Rhodes. She was born in Rocky Hill in 1889 and spent her childhood here. The Rhodes family was living in Wethersfield as early as the 1730s. Elsie's grandfather Talcott Rhodes, born 1810 in Wethersfield, was the first of the Rhodes family in Rocky Hill and established the Rhodes Farm.

Elsie was an army nurse in World War I and World War II. It's hard to believe by looking at this petite woman's picture, but the people who knew her report that she could handle any situation and swear like a drunk marine. You have to be tough to survive thirty years of service (1918–1947) in the company of professional soldiers in crisis conditions.

Elsie learned her nursing skills at Saint Mary's Hospital in New York City and practiced as a private service nurse in New Haven. She joined the

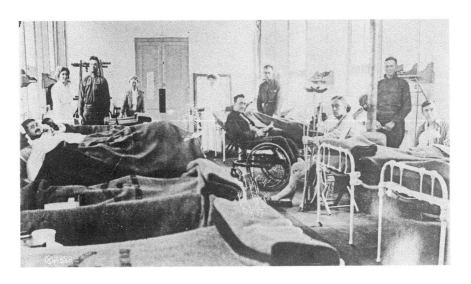

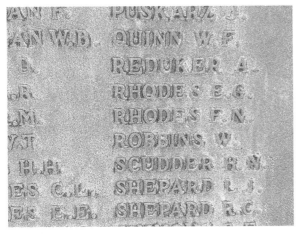

Above: World War I hospital. *Courtesy of the Library of Congress.*

Left: Elsie's name on the World War I monument. *Author's collection.*

army on March 11, 1918, and was later deployed to the General Hospital 2, Regular Army, in New York City. She was sent to American Expeditionary Force Hospital 41 in Paris, France, on July 18, 1918, just in time for the Second Battle of the Marne. The Allies incurred 139,000 dead or wounded, so this was a rough introduction to military nursing for Elsie. This battle turned the tide in favor of the Allies. The Second St. Mihiel Offensive was the first large-scale offensive launched mainly by the United States Army in World War I, and it resulted in 2,000 killed in action and 5,500 wounded. The Muese-Argonne Offensive was the last offensive of World War I, and it lasted from September 26 to the end of the war on November 11, 1918, and resulted in 26,277 dead and 95,786 wounded.

Elsie Rhodes's grave. *Author's collection.*

From July 1918 until her return to the United States in June 1919, Elsie must have been exposed to the horrors of war on a daily basis. On top of this, the Spanish flu, which was at its peak during this period, added to her workload and the dangers she faced.

Elsie returned from Europe on June 20, 1919, and served at Walter Reed Hospital in Washington, D.C. This was a strange interlude for her. She was relieved of military duty but not discharged. There seems to have been a question about whether nurses were regular military personnel and if they should be given benefits and postwar service. From a twenty-first-century perspective, one has to wonder, "How could you ask that?"

Elsie was commissioned as a second lieutenant and became part of the regular army. She served at several posts during her career, including Sternberg General Hospital in the Philippines. In 1943, she was the head nurse at the station hospital at Kelley Field in San Antonio, Texas. She was promoted to captain in 1940, major in 1942 and lieutenant colonel in 1947. She was discharged after thirty years of service in 1947.

Elsie came home to her family homestead and lived there until the 1960s, when the house was burned down by the Rocky Hill Fire Department to make way for development along Cromwell Avenue.

She then moved to an apartment in Hartford. She died on December 25, 1979. She was buried at Cedar Hill Cemetery. The struggle to preserve Elsie's memory continues. She is remembered on her family monument, but the monument is hidden by the branches of a large oak tree that reaches to the ground. Her inscription is in the lower left corner of the stone. It reads:

Lt. Colonel
Elsie G. Rhodes
1889–1979

Rocky Hill's World War I Orphan Heroes

Although we try to remember and honor our veterans, their stories sometimes fall through the cracks. This was almost the case with the Grant siblings: Florence, Leroy and Ralph. Florence's and Ralph's names are on the World War I monument on Center Green. The Grant siblings initially posed a mystery for researchers, which deepened as their research progressed.

Extensive genealogical research revealed that the three Grant veterans were the children of Charles Henry Grant and Mary (Cornish) Grant. Their daughter Florence was born in January 1888. Her brother Leroy was born on July 4, 1891. And Ralph was born on April 22, 1893. It also showed that, in 1900, the three siblings were classified as orphans. They had a sister named Lucy who died young, in 1906; she was born on January 4, 1890.

Something happened to the Grant parents between April 22, 1893, and 1900 that broke up the family. According to the 1900 U.S. census, Florence and Lucy were living with Charles Henry's brother Frank A. Grant, and Leroy and Ralph were living in the Hartford Orphans' Asylum.

Frank A. Grant was a stone mason who lived in Rocky Hill at 2594 Main Street (Middletown Road at the time). Charles Henry's daughters Lucy and Florence were living with him in 1900. Both girls were listed in the 1900 census as Frank's daughters. Lucy died in 1906, and in the 1910 U.S. census, Florence was listed as Frank's niece. Florence was active in the Rocky Hill Congregational Church. Articles in the *Hartford Courant* describe her activities, including being a soloist with the choir. She joined

the navy in 1918 and served at the New London Naval Facility in New London, Connecticut, as a stenographer/clerk. Florence was enumerated with Frank A. Grant in the 1920 U.S. census. So, she must have returned to Frank's home after her enlistment. She was listed as a government stenographer. Frank died on December 29, 1922. On May 25, 1923, Florence was named the executor of Frank's will. Sometime between 1920 and 1924, Florence was married; moved to Casper, Wyoming; and became pregnant. She died of peurperal septicaemia, a type of blood poisoning that accompanies childbirth, on February 14, 1924, and she was buried at Rocky Hill Center Cemetery. There was no mention of her husband or a child in her *Hartford Courant* obituary.

Leroy (listed as "Roy") Grant and Ralph Grant were listed orphans in the Hartford Orphans' Asylum in the 1900 U.S. census. Leroy left there in 1909, when he was eighteen, and Ralph left two years later, in 1911. Both men seemed footloose, adventurous and willing to relocate and adapt at an early age. Leroy was in Otisco, New York, working as a farmhand when he enlisted in the army in May 1918. He served as a horse wrangler in the cavalry at Camp Dix, New Jersey. He had previous experience in the U.S. Navy. He was working at the Sutton and Kelley Company in Milwaukee in 1942, according to the World War II Old Man's Draft. He died in Milwaukee, Wisconsin, in 1967.

After leaving the orphanage, Ralph worked as a farmhand in Berlin, Connecticut. He then moved to Wyoming and became a cowboy. Ralph was inducted into the army in 1918. He served in the Seventh Engineers Regiment of the Fifth Infantry Division, whose duties involved building fortifications and blowing up enemy fortifications. On his 1918 army passenger transport list, his next of kin is listed a "Florence Grant (sister) of Rocky Hill." Ralph either stayed in the army or reenlisted in 1931. There is a record of him returning from Hawaii on a military transport ship in 1931. Ralph was working at the Lake Washington Shipyards in King, Washington, when he enrolled in the Old Man's Draft in 1942. Ralph died in 1977 in King, Washington.

Questions about the veterans being parentless orphans remain. Charles Henry Grant married Margaret Stewart in Boston in 1906. There is no question that this man was the father of the three veterans and Lucy. His birth date, place of birth and the names of his parents are the same as their listed father. According to the 1910 U.S. census, he was running a rooming house with Margaret and worked in a Boston foundry. The record states that this was his first marriage, which we know it wasn't. Was he on the run,

avoiding his responsibilities as a parent? Did his children know where he was? Did he keep in touch? One has to wonder—did he know that while he was starting a new life in Boston, his daughter Lucy was dying in Rocky Hill?

The fate of Mary (Cornish) Grant remains elusive. Why wasn't she available to look after her children? Was she dead, incapacitated, overwhelmed, missing—or something else?

THE FIRST PANDEMIC IN ROCKY HILL

1918–1920

The COVID-19 virus of 2020 was not the first to sweep through Rocky Hill. From 1918 to 1920, the Spanish flu swept the world. World War I was raging at the time, and governments suppressed news about the pandemic to avoid panic and distractions from the war effort. Spain, which was a neutral country, reported the dangers of the flu accurately and candidly. Consequently, the flu became known as the Spanish flu, although Spain had nothing to do with it.

The flu spread worldwide, killing people as it went; 3 to 5 percent of the world's population, or one in twenty people, died. Population centers like Hartford were the hardest hit. In a time when travel was more limited and populations were more dispersed, rural communities like Rocky Hill suffered less, although it was still seriously hurt. The 1919 annual report for Rocky Hill stated, "There were 144 cases of Spanish influenza and probably less than half of the cases were reported." Rocky Hill's population at the time was approximately 1,300. In spite of a dearth of information from the government, as it became clear to people that something was wrong, meetings and church events were cancelled or held in small groups due to "illness."

Dr. Oran Moser, the town's country doctor, made a valiant effort to fight the flu. As he spent exhaustive hours making house calls and writing newspaper articles to contain the panic, his wife contracted the flu and died from it. Dr. Moser contracted the flu himself but survived.

While most pandemics take their greatest toll on the infirm, the very young and the very old, this one killed a disproportionate number of young adults,

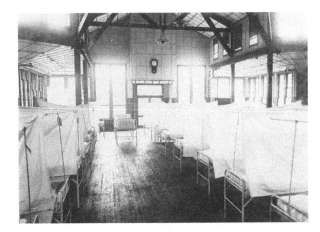

Left: Spanish influenza ward. *Courtesy of the Library of Congress*.

Below: World War I soldiers—no face masks or social distancing. Connecticut Fights: The Story of the 102nd Division, *book in the public domain.*

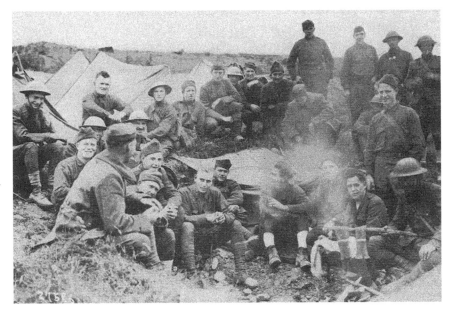

particularly men who were grouped in close contact at military facilities. Camp Devens in Massachusetts and Camp Upton on Long Island, where soldiers from Rocky Hill trained, were two of the hardest hit places.

Several Rocky Hill veterans may have been touched by this scourge. Walter E. Bittner was conscripted into the National Army and arrived in England on October 18, 1918, already sick with the flu. He was admitted to the hospital immediately and was there when the war ended. When he filled out his service record on December 31, 1918, he stated that he was still ill from the effects of the flu.

A more tragic case was that of Clifford L. Holmes. He may have contracted influenza as early as April 28, 1918, when he was called to the local draft board in East Hartford for an examination. He decided to get married before he left. He was scheduled to report for duty the day after he was married, but he was admitted to Hartford Hospital with influenza instead. He died there the same day. In a small town like Rocky Hill, this generated a lot of emotion and sympathy, and it seemed to result in the Campilio-Holmes Post of the American Legion being named for him. The Connecticut adjutant general has no record of his service, and it is possible that he was never actually inducted.

Several other veterans reported medical problems after March 1918, although it isn't clear if the problem was influenza. Sidney Templeton was admitted to the medical department at Camp Devens immediately after his arrival. Ruth Chandler was reported to be ill at Camp Meade, Maryland, in October 1918. Albert Francis Warner was reported to be under medical care on December 17, 1918.

THE GREAT FIRE OF 1921

From the early days of the town until 1927, fire protection was provided by ad hoc groups of townspeople who responded to alarms issued from the bells of the Congregational church to form bucket brigades. A volunteer fire department was formed in Wethersfield in 1803, but given that transportation was on foot or horseback, the response from Wethersfield was not help when a fire started. Disastrous fires were a part of Rocky Hill life before 1927. For instance, Academy Hall burned to the walls in 1839, and the foundry burned to the ground in 1865 and 1918. Fires on farms were common occurrences. Articles in the *Hartford Courant* show that domestic fires were an everyday occurrence, and although the community rallied in the face of misfortune, protection from fire was considered an individual responsibility.

That all changed in 1921. Elwood Belden owned a store on the west side of Old Main Street, between Academy Hall and the Congregational church. There was also the Grange Hall, a barbershop, a gristmill and storage sheds used by Belden in this area. A dirt path, which became Center Street and later Church Street, ran between the Grange Hall and Belden's Store. There was room for all these buildings because the Congregational church's parish house, which was added in 1946 and extended north, doubling the size of the church, hadn't been built yet.

The fire occurred as a result of a petroleum fire at Belden's Store. Belden's Store provided one of the town's early gas pumps and had a large storage tank to service it. Belden also had a large storage tank from which he sold

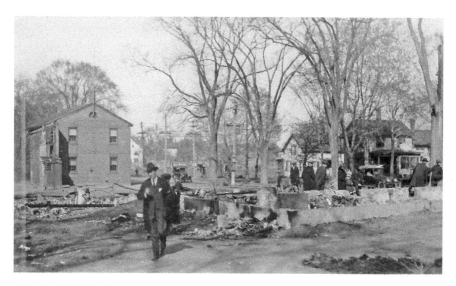

After the 1921 fire. *Courtesy of the Rocky Hill Historical Society.*

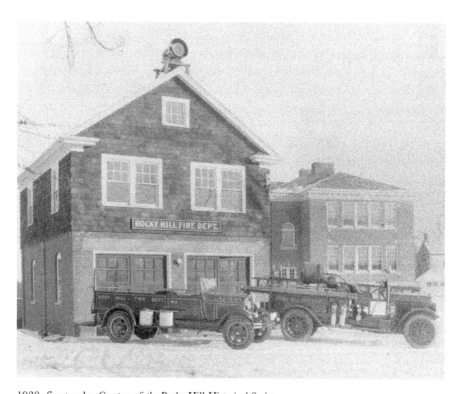

1930s fire trucks. *Courtesy of the Rocky Hill Historical Society.*

kerosene. On April 21, a fire started and engulfed every building within the area encompassed by today's Academy Hall, the Congregational church, Old Main Street and Church Street.

The bucket brigade protected the Congregational church and Academy Hall, but all the other buildings were burned to the ground before fire equipment from Wethersfield and Hartford finally arrived and brought the fire under control.

A town meeting was called on April 27, 1921, to address the need for fire protection, but because of resistance from "rugged individualists," nothing came of it. The need for fire protection was finally acknowledged in 1927 with the purchase of a pumper and the construction of the firehouse, which is now the fire museum.

ROCKY HILL WOMEN
AND WOMEN'S SUFFRAGE

The word *suffrage* comes from the Latin *suffragium*, which initially meant "a voting tablet," "a ballot," "a vote" or "the right to vote." In 1918, the women's suffrage movement was on the verge of success. Opponents of the Nineteenth Amendment and defenders of the status quo were becoming increasingly desperate and angry. The war gave them one last line of defense: they claimed that the question of women's suffrage should be deferred in order to focus entirely on the war. Advocates of women's rights were having none of this. They pressed for the Constitutional amendment that would guarantee women the right to vote. Events got heated on a national level, including picketing and signage that portrayed President Wilson as an American Kaiser, because, they argued, just as the Kaiser denied his people basic rights, Wilson was denying women their rights. The response from opponents of suffrage was immediate and violent. Women were beaten, arrested and jailed. When they staged a hunger strike, the federal authorities force-fed them by snaking feeding tubes down their throats. These abuses forced the issue for President Wilson, who had been waffling on the suffrage issue. He came out in favor of women's suffrage, ensuring its passage.

At the time, Rocky Hill was primarily a farming community, although there were a few commuters riding the trolley and railroad to jobs in Hartford and Middletown. Farming people have traditionally been at the mercy of nature and, consequently, have approached change cautiously. The late 1910s were unprecedented times, much like today. National borders

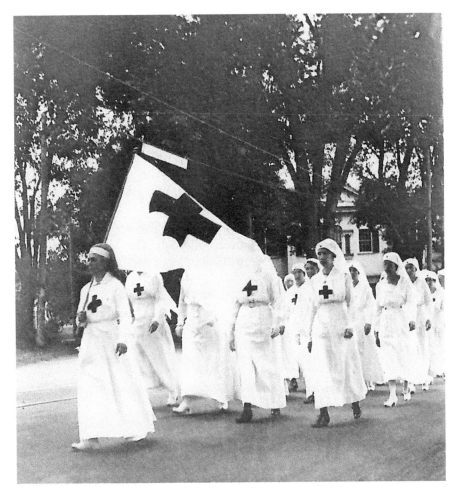

Rocky Hill Red Cross. *Courtesy of the Rocky Hill Historical Society.*

were being redrawn, the Spanish flu pandemic was raging, World War I was ending and radical political movements like communism, socialism and anarchy were in ascendance. Cautious people proceeded slowly.

The war period, from 1917 to 1920, was an active time for Rocky Hill women. Total war demanded total mobilization of all the nation's resources. Manpower had to be channeled to the front. Behind the lines, labor had to be redirected from less necessary activities. Agriculture had to be mobilized to provide for the needs of both civilians and soldiers. Rocky Hill's women rolled up their sleeves and did most of the grassroots work of fundraising, conservation and the provision of material goods to support the troops.

Several local organizations worked together to get things done. The Rocky Hill chapter of the Red Cross was run by women and operated under the auspices of the Motherhood Club. A statewide group, the Women's Committee on Food Conservation, gave canning demonstrations and distributed conservation literature from the Hartford County League and Storrs Agricultural College, later the University of Connecticut.

Communications weren't as readily available then as they are today. There was no twenty-four-hour news cycle, no social media. Radio was an emerging technology, but it was primarily an esoteric interest for hobbyists. People got their information through word-of-mouth communication, newspapers, public meetings and church attendance.

A sense of women's opinions on suffrage during this period can be gained by reading the minutes of the Motherhood Club. The Motherhood Club was the precursor of the PTA. At the beginning of each meeting, the "Ten Commandments of Womanhood," an affirmation of the status quo for women's roles, was read. The women's rights movement wasn't just a battle of the sexes. The fact that a vote on women's suffrage by the Motherhood Club ended in a tie indicates that opinions among women about suffrage was divided.

The Ten Commandments of Womanhood
Nineteen Hundred and Eighteen

Thou Shalt Not Waste Time, *for idleness is shame and sloth a mockery; and Lo! The day cometh when thy men shall be called from the harvest and their workshops stand empty and silent.*
Thou Shalt Not Waste Substance, *for once, thrice and ten times shall thy country call upon thine household for gold, and woe betide the land if at the last their purses be found bare.*
Thou Shalt Not Waste Bread, *for every fragment that falls idly from thy board is withheld from the mouths of thine allies' children and the kits of thy sons and brothers in the trenches.*
Thou Shalt Not Bedeck Thyself Lavishly, *for the silk upon the back and the jewel upon thy breast are symbols of dishonor in the hour of the Earth's agony and thy nation's need.*
Thou Shalt Not Be Vain and Self-Seeking, *for the froward* [difficult to deal with] *and jealous heart judgeth itself in the sight of the Lord; and in time of world travail who shall say to her sister, "I did it, and those did it not."*

Hearten Thy Men and Weep Not, *for a strong woman begetteth a strong man, and the blasts of adversity blow hard. And swift across the world.*

Bind Up the Wounds of Thy Men and Soften Their Pain, *for thy presence by the light of their campfires is sweet and graceful, and the touch of thy hand deft in the hour of need.*

Keep Thou the Faith of Thy Mothers, *for in the years of thy country's sacrifice for independence and union, they served valiantly and quailed not.*

Keep Thou the Family Fruitful and Holy, *for upon it, the Lord shall rebuild his broken peoples.*

Keep Thou the Lord Thy God with Diligence, *for His houses of worship shall not be empty, not His altars unvisited in years of His mighty chastening.*

Several events were held during this period in Rocky Hill to raise the public's consciousness of women's suffrage. A meeting was held in Rocky Hill's Grange Hall in March 1912 to welcome people from the suffragists' Trolley Campaign, a movement that used the trolley system to reach people around the state. Several Rocky Hill people canvassed the town to solicit support for this. By February 1918, the suffrage movement had gained support, as witnessed by a sermon from Morris E. Alling, the minister of the Rocky Hill Congregational Church in March 1918. He voiced unequivocal support for suffrage while upholding the principles of the "Ten Commandments of Womanhood." The Senate Suffrage Special, an effort involving decorated automobiles that toured the state promoting suffrage, came to the Grange Hall in March 1918. By this time, many of the town's opinion makers supported suffrage, including Mrs. Louis Button, the wife of Louis Button, an influential insurance and real estate broker and judge who once held four town offices simultaneously. Suffrage had clearly gained significant support.

At least one Rocky Hill woman took a radical stance. The following article appeared in the June 27, 1918 edition of the *Hartford Courant*:

ROCKY HILL WOMAN ATTACKS PRESIDENT
Federal Agents to Probe Refusal to Buy Thrift Stamps

When approached by an authorized solicitor for war savings stamps, Mrs. Jason A. Robins [sic], who lives on Riverside Hill here, is alleged to have called President Wilson the "Yankee Kaiser" and said that Germans will

win the war, as well as several other unpatriotic utterances. She refused to subscribe for any stamps, and when requested to fill out the blue card given her for so doing, tore it in pieces. Recently, when approached by a solicitor for Liberty bonds, Mrs. Robins made an unpatriotic attack, using language unfit for publication. The woman's husband is said to be one of the wealthiest men in town as the grand list shows. The matter has been put in the hands of agents, who will investigate.

Jane Robbins was the seventy-five-year-old wife of Jason "Gus" Robbins, who owned the large house at 54 Riverview Road. He owned a large apple orchard across the street and was quite influential in town politics. At first blush, this seems to be a story about a wealthy, pampered, unpatriotic and possibly crazy old lady who needed to be investigated. Deeper research tells another story. While she may have been more zealous than her peers, she seems to have been typical of many prominent, well-educated women in the late 1910s. As often happens in difficult times, the women of Rocky Hill were forced to make a choice: total commitment to the war, total commitment to suffrage or something in between. Apparently, Mrs. Robbins stood firmly on the side of suffrage.

On August 18, 1920, the Nineteenth Amendment was ratified, acknowledging women's right to vote as part of the U.S. Constitution, forty-two years after its first introduction into Congress. The role of women in the United States changed irrevocably. In 1920, out of twenty-nine Rocky Hill town officers, only one, a member of the school committee, was a woman. In 2020, a quick survey of www.rockyhillct.gov showed that women, including two recent mayors, were an important presence in the operations of our town.

Bonus Marchers and the Birth of the Rocky Hill Veterans' Home

In the aftermath of every war, veterans return home to face the challenges of integrating themselves back into civilian life. This was the case in the early twentieth century, when millions of World War I veterans joined the civilian population.

When the veterans returned, many were able to find their niches in society, but the Great Depression proved that these niches were not as secure as they seemed. These people had been promised the support of a "grateful nation," but when they called on that support, they found doors closed to them. They asserted themselves aggressively to claim what they considered their rights. The result was disturbing changes in the way "a grateful nation" dealt with its veterans.

The Fitch's Home for Soldiers and Their Orphans was founded on July 4, 1864, in the Noroton Heights section of Darien, Connecticut. It was intended for the care of disabled Civil War veterans and the orphans of Civil War soldiers who had been killed in the war. Established by Benjamin Fitch, a Darien philanthropist, the facility, in its early years, focused on orphans. It was built in a time when petitioning for assistance was considered an admission of failure, and few veterans were willing to live with the disgrace.

Benjamin Fitch died in 1883 and left an endowment for the upkeep of the home. But even with this support, the home deteriorated. By 1888, the State of Connecticut assumed responsibility for its operations. By then, the orphans had grown up and moved out.

The population of the home became small and manageable and consisted of a few veterans from the Civil War, the wars against Natives, the Spanish-American War, the Mexican Punitive Expedition, the Philippine Insurrection and small conflicts in the Caribbean and Central America. To the institution's credit, at a time of rampant racism, a significant number of veterans at Fitch's were Black. They had served as buffalo soldiers (a term for Black soldiers who had served on the Western frontier) and with Black Jack Pershing, who led Black troops during the Spanish-American War and who later became the commander of American forces during World War I.

By the early twentieth century, Fitch's Home had become an integral part of the Darien community. The veterans who were living there participated in town parades, while local volunteer organizations performed various services for the home.

In 1920, 250 veterans lived at the home. Life was simple, and nobody seemed to anticipate the tsunami of World War I veterans who were about to swamp the facility. World War I resulted in a large influx of veterans. Many of them suffered from conditions, including metal health issues, substance abuse and post-traumatic stress disorder, which were poorly understood at the time. These conditions manifested themselves as behavioral disorders and weren't treated as disabilities. Admission to Fitch was usually limited to physical disabilities. In 1929, at the start of the Great Depression, the home hosted 217 veterans.

In 1924, with patriotic fervor at its peak and the economy booming, the United States Congress decided to provide a pension for those who had served in the military. The fund was to accrue interest and be payable in 1945.

The Great Depression put otherwise productive men, including many veterans, out of work. The term used for these people was "forgotten man." Songs and movies of the era provide a sense of time. Songs like "My Forgotten Man" and "Brother Can you Spare a Dime," and films like *Wild Boys of the Road*, *Grapes of Wrath* and *My Man Godfrey*, capture the desperation on the times. The public wanted to help, but nobody had any money.

Destitute veterans wanted their bonuses paid out early. In the spring of 1932, seventeen thousand World War I veterans and their families, including at least thirty-five veterans from Connecticut, converged on Washington, D.C., and set up camp at Anacostia Flats. They hoped to sway public opinion and pressure the U.S. Congress to approve an early distribution of the bonuses. The press and the public called these veterans the Bonus Army.

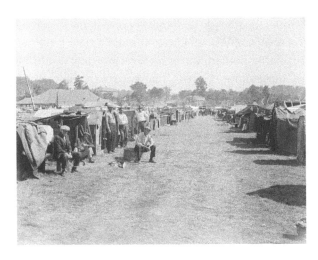

Bonus army shacks. *Courtesy of the Library of Congress.*

Unfortunately, the gathering in Washington caused a backlash of negative public opinion toward the veterans. A powerful bloc mobilized to paint these veterans as slackers and subversives. Congress rejected the notion of paying the bonuses early. On July 7, 1932, the U.S. attorney general ordered the veterans to be removed from government property. The Washington, D.C. police accomplished this using force. When the Bonus Army reoccupied the site, the police opened fire, killing two veterans. President Hoover ordered the army to clear the site. General Douglas McArthur exceeded his authority. He ordered a cavalry charge, followed by a bayonet and tear gas attack supported by six tanks.

President Hoover ordered a halt, but McArthur continued dispersing the veterans, wounding 55 of them, jailing 135, killing 1 pregnant woman and burning down the shacks the marchers lived in. There was substantial public outcry over the brutality of this assault and widespread public sympathy for the veterans.

On August 7, 1932, the twenty-five Connecticut refugees from the Bonus Army arrived home from Anacostia. Sympathy for them was high. Fitch's Home was unable to absorb this new wave of veterans. The men were sent to the Veterans' Supply Farm in Rocky Hill. The Rocky Hill Supply Farm had been owned by the Hartford Retreat, a privately owned, state-regulated mental facility, and had been acquired on January 4, 1932, to provide dairy products and produce to Fitch's Home.

There was no room for the veterans in the few buildings at the supply farm, so they were housed in tents and fed from a mobile kitchen provided by the Connecticut National Guard.

The question was: what would the state do with these people in the long run?

A plan was proposed to Governor Wilbur Cross to build a new veterans' home at the supply farm for able-bodied, destitute veterans that would be modeled on the Civilian Conservation Corps. The governor rejected the idea, arguing, "The proper care of veterans needing relief is the duty of the state.…At Rocky Hill, all who need care can get it—not as charity, but as an expression of Connecticut's appreciation for the services of the veterans."

This marked a change in the mission of the state's veterans' homes from the care of disabled veterans and orphans to the provision of relief to veterans in need. By 1936, there were more than one thousand veterans in the two facilities. Overcrowding at Fitch's Home had become untenable. Cots were set up wherever there was room, including in the chapel, where they had to be removed on Sundays for services.

In 1936, Congress reversed its decision and authorized the immediate payment of the bonuses. It was expected that the payments would induce veterans to leave the homes. However, there is an old military expression that says, "You eat a lot of beans on the outside." Few veterans were eager to leave. Word that there was a haven for veterans at Rocky Hill spread rapidly, and more veterans were entering the homes than were leaving. It was clear that a more permanent solution than tents and mobile kitchens was needed. Plans were solicited for a new veterans' home. After years of

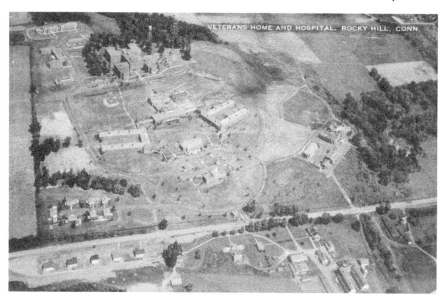

Rocky Hill Veterans' Home, circa 1940s. *Courtesy of the Rocky Hill Historical Society.*

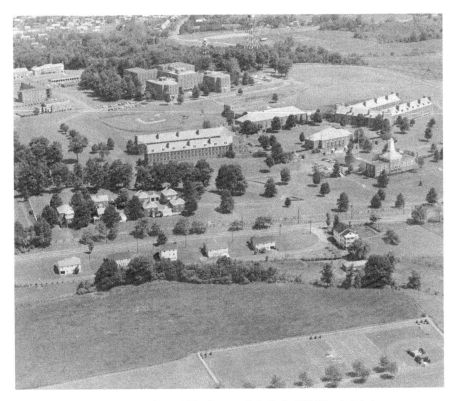

Rocky Hill Veterans' Home, circa 1969. *Courtesy of the Rocky Hill Historical Society.*

political jockeying, in 1936, it was agreed that that Fitch's Home either had to be remodeled or replaced.

The location of veterans' facilities in Connecticut was a hot-button issue in the 1930s. There was intense competition among towns for the sources of revenue and jobs that visitors, suppliers and other support organizations might provide. The opening of a veterans' hospital in Newington in 1931 was an example of this. Competition to host the hospital was fierce between Windsor, New Haven and Newington. Newington won because it was located in the center of the state and was easily accessible from many other locations.

The competing sites for a new veterans' home that was to replace Fitch's Home were Darien, West Haven and Rocky Hill. West Haven's leaders wanted the new home because it was the site of the veterans' tuberculosis hospital that the city hoped to expand. Greenwich County politicians fought to keep the home where it was, since Fitch's Home has been part of the Darien community since 1864.

When the dust settled, Rocky Hill emerged as the winner. The Rocky Hill facility was new, while the Fitch facility was showing its age. Rocky Hill was in the center of the state, and it was close to the Newington Veterans' Hospital.

The veterans moved out of Fitch's Home on August 28, 1940, departing from Noroton Train Station on a special train consisting of four coaches and two baggage cars. After arriving at the Rocky Hill Station, the men were bused to the new facility at 287 West Street.

The number of veterans in the system in 1940 dramatizes the impact of World War I on the Connecticut veterans' system. Before the move, the 1,000 veterans at Rocky Hill were primarily veterans of World War I. The veterans from Fitch added 1 Civil War veteran, 10 Mexican Expedition veterans, 1 Indian Wars veteran, 50 Spanish-American War veterans and 499 World War I veterans. There were also 63 veterans from other wars and 1,500 from World War II.

The Rocky Hill facility originally comprised only the supply farm. In 1940, the Gilbert family sold 150 additional acres to the state. In 1968, 60 acres of this land were given to the Town of Rocky Hill by the general assembly for the formation of Dinosaur State Park. Some of the remaining land contains the Raymond F. Gates Cemetery for veterans and housing for staff.

The current home comprises forty red-brick buildings that were acquired from the Gilberts. The home's mission evolved based on the influx of World War I veterans. As wars became more frequent and involved ever-larger standing militaries, the demand for veterans' services has continued to increase, and the mission of the home has continued to evolve. The home has evolved from a haven for a handful of disabled Civil War veterans and orphans to a large chronic disease treatment center for veterans of several wars.

Rocky Hill's Richard Cory

Whenever Richard Cory went downtown,
We people on the pavement looked at him:
He was a gentleman from sole to crown,
Clean favored, and imperially slim.
And he was always quietly arrayed,
And he was always human when he talked;
But still he fluttered pulses when he said,
"Good-morning," and he glittered when he walked.
And he was rich—yes, richer than a king—
And admirably schooled in every grace:
In fine, we thought that he was everything
To make us wish that we were in his place
So, on we worked, and waited for the light,
And went without the meat, and cursed the bread;
And Richard Cory, one calm summer night,
Went home and put a bullet through his head.

Simon and Garfunkel released a song in 1966 based on this poem. It could easily be about Owen R. Havens.

Owen R. Havens was the blue blood descendant of Revolutionary War soldier Owen Renwick and a member of the Sons of the Revolution. He belonged to all the influential clubs and lodges, including the Rocky Hill Businessman's Club and the Masons. He was born in Wethersfield in 1856. He began his working life as a traveling salesman for a seed company

and opened a meat market in New Hartford in 1881. He came to Rocky Hill in 1885 and opened a retail hay company, which he ran until 1910. From 1899 to 1912, he was the president of the Champion Manufacturing Company, which later became the Connecticut Foundry. In his role as president of the Dime Savings Bank, he served as administrator and/or executor for several large estates.

As an active member of the Republican Party, Havens served as first selectman of Rocky Hill from 1896 to 1908, except for one term that was served by Elwood Belden. He represented Rocky Hill in the general assembly in 1893 and 1897 and was a delegate at the Connecticut Constitutional Convention in 1899. He had a fascination with criminal justice, volunteered for most grand and petit juries and attended criminal proceedings whenever he could.

Havens served as the Rocky Hill–Glastonbury Ferry co-commissioner with F.D. Glazier, who owned the Glazier Wooling Mill on Roaring Brook in South Glastonbury. The ferry was the essential economic lifeline to get South Glastonbury commercial goods across the river to the railroad station in Rocky Hill. Havens and Glazier worked for several years to replace the decrepit ferry the *Rocky Hill* with the more powerful, more spacious *Nayaug*.

The great fire of 1921 made it clear to most people that Rocky Hill needed an effective fire department. A committee was formed, and a report was submitted that advocated for the establishment and financial support of a volunteer fire department. Havens fought the establishment of a fire department and managed to delay it for seven years. In subsequent years, the fire department was established over his objections, but he fought every move to fund or improve the department. Whether Havens was prompted to do this by a sense of propriety, fiscal conservatism or political rivalry cannot be determined.

Owen Havens shot himself in the head with an antique pistol in his home at 132 Old Main Street on April 23, 1934, the day he was scheduled to testify about his administration of the estate of George Allen of Hartford, who had died on August 11, 1931. He was called to explain payments he claimed to make to George Allen's wife, Caroline, in his role as the administrator of this estate. Caroline Allen had died on January 25, 1933, and Mrs. Frank Rowley, her heir, said that the payments Havens claimed were never made. Mrs. Rowley's attorney filed a motion to replace Havens as the administrator of the Allens' estate.

Caroline Allen had left her estate, valued at about $4,000 ($76,534 in 2021), to Havens and Rowley in equal shares. Havens was the administrator

Owen Havens's home at 132 Old Main Street. *Author's collection.*

of the estate of George Allen and the executor of the estate of Caroline Allen. You have to question why Caroline Allen would give half of her estate to an executor with fiduciary obligations to her other heir, Mrs. Rowley. This seemed to create a conflict of interest and an invitation to contention.

On review, a line item in the estate that Havens had valued at $175.22 ($3,352.00 in 2021) was revalued by the auditor for $3,829.39 ($73,269.00 in 2021), a substantial difference. The auditor said that Havens "comingled the funds of the two estates together in a manner which, though it may have been understandable, is extremely perplexing to anyone else who undertakes to untangle the figures."

Another question arose. George Allen had left an estate of $12,000, ($229,602 in 2021). Caroline Allen had left an estate of $4,000. What happened to the rest of the money?

Havens was dead, and his estate needed to be adjudicated as well. A compromise was reached to partially compensate the heirs of Caroline Allen while preserving the estate of Owen Havens for his wife. Havens was later found to have defrauded the estate of Rose McNally when he acted as its administrator. Again, his wife was held blameless because she had no knowledge of the fraud.

Why did Owen Havens end his life? Part of the answer may lie in the events of this period. The great Wall Street crash occurred, and the Great Depression started in 1929. Boom times yielded to financial pressure and desperation. Was Havens guilty of malfeasance, or did he simply get rattled and make mistakes? We'll probably never know.

EIGHT MARKERS FOR FALLEN HEROES

Among the many historical reminders in Rocky Hill's Center Cemetery are eight stones, all in a row, that memorialize World War I and World War II heroes who died and were buried overseas.

ANTONIO CAMPILIO

The first, westernmost stone is for Antonio Campilio. He was the only Rocky Hill soldier killed on the battlefield in World War I, although several were wounded and later died of their wounds. Antonio's marker reads:

World War
Antonio Campilio
HO Co 0103D FA
Died July 25, 1918
Age 30
Buried in France

Antonio was born on April 11, 1890, in Jungla, Italy, and had been a private in the Italian army. He emigrated to the United States in 1909. He was drafted into the National Army on November 19, 1917.

In July 1918, eight American divisions were involved in the French-led Second Battle of the Marne. This was a mobile attack by infantry supported

World War II Rocky Hill heroes buried overseas. *Author's collection.*

by machine gunners and engineers. It was an extremely bloody battle with large numbers of American casualties. The dead and wounded reached 20 percent of the Allied troops engaged in this battle.

The Campilio-Holmes American Legion Post in Rocky Hill is named for Antonio Campilio.

HORACE AND FRANK BENNINO

Both Bennino brothers were killed in France in 1944. Private First Class Horace Bennino was killed in action on June 24, and a few weeks later, on August 6, Corporal Frank Bennino was killed in a motor vehicle accident. Their father, Nunzio Bennino, was a veteran of World War I from Rocky Hill. Horace's marker reads:

> *World War II*
> *Horace J. Bennino*
> *Co. M, 315th Inf.*
> *Died June 24, 1944*
> *Age 22*
> *Buried in France*

Frank's marker reads:

World War II
Frank J. Bennino
Tech GR. 5
HQ Det 321ˢᵗ Ord Bn
Died Aug. 6, 1944
Age 22
Buried in France

Frank Bennino was killed eighteen days after D-Day. He received a Silver Star posthumously for his gallantry. Its citation reads:

> *On June 22, 1944, in France, when the advance of his company was impeded by an enemy mortar barrage, he undertook to carry a message back to a mortar platoon, which was out of communication due to severed lines. He fought his way through the enemy barrage, and despite the fact that he was wounded, he succeeded in delivering his message, thereby causing the elimination of the enemy mortar emplacements. His indomitable courage and valiant determination to carry out his mission despite his wounds reflect highest credit on himself and the Armed Force of the United States.*

ELLIS BECK

Private Ellis Beck was born on March 14, 1922, in Worchester, Massachusetts. He attended Wethersfield High, the University of Connecticut. He was a noted athlete, especially in soccer, and was a member of the enlisted reserve corps. He was called up in March 1943. After basic training, he was sent to the University of Pennsylvania to study engineering. When this program was discontinued, he went to Indiantown Gap, Pennsylvania, then to Seneca Mountain in West Virginia, where he graduated in July 1943 and shipped out for France.

He was killed in action in France. On November 8, an assault began to take the city of Metz. He was reported missing in action on November 10, 1944, and later found to have been killed in action on that date.

World War II
Ellis A. Beck
Co I 377ᵗʰ INF
Died Nov. 10, 1944
Age 22
Buried in France

RICHARD DEXTER

Richard Dexter was born in 1921. He graduated from Wethersfield High and was a student at Trinity College in Hartford when he entered the army air corps in June 1942. He qualified as a gun turret maintenance man at Lowry Field in Denver, Colorado.

He went overseas in January 1943 and joined the veteran B-25 Mitchell bomber group the 445th Bomber Squadron, which had been cited by President Roosevelt for outstanding performance in action against the enemy. He was involved in the first mission over Rome and flew missions over the Balkans. He was killed in action over Corsica on December 3, 1944.

World War II
Richard W. Dexter
Died Dec. 3, 1944
Age 23
Buried in Corsica

ALBERT GOSS

Private First Class Albert Goss was a marine. It was reported that he was killed in action at Eniwetok on July 31, 1944. The United States conducted nuclear tests on Eniwetok starting in 1953. It is unclear if the graves of Americans on Eniwetok were relocated or if they were lost in the nuclear explosions.

World War II
Albert B. Goss
Co E 3D Regt 3rd Marines
Died July 31, 1944
Age 20
Buried on Eniwetok

HENRY GOULD MAXHAM

Staff Sergeant Henry Maxham was born in Hartford, Vermont, on January 28, 1912. He enlisted in the army air corps after Pearl Harbor, received

his wings in Las Vegas, Nevada, and went overseas in September 1942. He completed fifty-two missions and returned to the United States but volunteered to return to active duty and was sent to England.

He was a much-decorated tail gunner on a B-17 and flew over seventy missions in his career. He was awarded the Air Medal with six oak leaf clusters. He was also awarded four battle stars. He was killed over Germany on Christmas Day in 1944.

World War II
Henry G. Maxham
S/Sgt
565ᵗʰ Bomb Sq
Died Dec. 25, 1944
Age 32
Buried on Belgium

ARMOND CHAPRON

Private Armond Chapron was born in Methuen, Massachusetts, on October 19, 1915. His family moved to Rocky Hill in 1929. He attended Center School, and upon his graduation, he was employed at the Hartford Rayon Corporation.

He was drafted in March 1941 and served with the Twelfth Armored Division of the Seventh Army. He arrived in Europe in March 1945. He was killed in action in Germany on April 22, 1945, while serving with Troop B, Ninety-Second Division, Cavalry Reconnaissance Battalion under General George Patton. The war in Europe ended on May 8, 1945, fifteen days later.

World War II
Armond Chapron
Trp. B 92ⁿᵈ Cav Recon B
Died Apr. 22, 1945
Age 29
Buried in France

FINDING THE MEMORIALS

You can find these stones and honor these fallen heroes by going to the flagpole in the cemetery and following the dirt road to the east of the Robbins crypt. The memorial stones are just southeast of the crypt.

SUBURBANIZATION

For much of Rocky Hill's history, its population has been limited by the ability to travel to and from Hartford and Middletown. Originally, the only access points to the town were crude dirt roads. A chart of the population of Rocky Hill shows quantum leaps in the population as the means of conveyance to and from these nearby cities became more efficient and accessible. The population grew from 791 in 1870, a year before the railroad arrived, to 1,187 in 1910. It grew by one-third when the trolley came through. With the arrival of the Silas Deane Highway, it jumped from 2,021 in 1930 to 5,108 in 1950 (even though the Great Depression and World War II impeded migration). Interstate 91 caused a quantum leap in population, from 7,404 in 1960 to 14,559 in 1980, and fundamentally changed the nature of the town. Rocky Hill went from being a primarily farm-based community to a thriving suburban residential community.

RAILROADS, TROLLEYS AND BUSES

The Valley Railroad began stopping in Rocky Hill in 1871, making it practical for people to commute to Hartford and Middletown. In the oral history *Harry Hick and Samuel Dimmock: Late 19th, Early 20th Century*, Harry Hick describes the daily event of the train stopping at the Rocky Hill station and the daily rush of commuters running to catch it. In its early

Year	Population	Event
1756	880	
1775	880	
1779	881	
1850	1,042	
1860	1,142	The decline of Rocky Hill maritime industry.
1870	791	The railroad arrives.
1880	1,108	
1910	1,187	The trolley begins in 1909.
1920	1,633	
1930	2,021	The Silas Deane Highway opens.
1940	2,679	
1950	5,108	
1960	7,407	In 1963, Interstate 91 reaches Rocky Hill.
1980	14,559	
1990	16,554	
2000	17,966	
2010	19,709	

days, the railroad was the town's only means of mass transit, and if you missed it, you missed a day of work.

Commuting became easier in 1909, when the electric trolley service started. It ran from Hartford, down Farmington Avenue and Wolcott Hill Road in Wethersfield, across farms and woodlands, through Griswoldville, across where Parsonage Street now crosses the Silas Deane Highway and then to the corner of Old Main and Washington Streets, where there was a stop. The trolley then ran up Old Main Street and the Saybrook Turnpike to Middletown. The Connecticut Company replaced the trolley with a bus service in 1931.

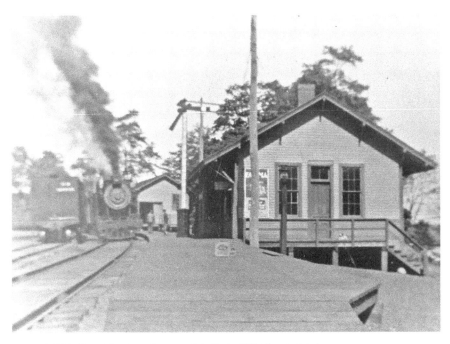

Rocky Hill Railroad Station. *Courtesy of the Rocky Hill Historical Society.*

Rocky Hill trolley. *Courtesy of the Rocky Hill Historical Society.*

Silas Deane Highway. *Courtesy of the Rocky Hill Historical Society.*

SILAS DEANE HIGHWAY

By 1930, the automobile era was in full swing. The Silas Deane Highway opened in that year, and commuting to Hartford by automobile became common. It is worth noting that, as recently as the 1960s, the Silas Deane Highway in Rocky Hill was a sparsely populated strip, with a few farm stands and shops along it—not the backbone for strip mall after strip mall it has become. In a private conversation, Ralph Hick told a story about his father, Harry R. Hick, carpooling to work on the Silas Deane to Aetna Life and Casualty in Hartford. One member of the pool traveled from far-away Higganum.

INTERSTATE 91

Interstate 91 fundamentally changed the town, as it made it practical for people to leave crowded cities, such as Hartford, Middletown and New Haven, to buy a comfortable, affordable home in the suburbs. Wethersfield had been thoroughly suburbanized by 1960, and Rocky Hill was the next logical place to expand. This expansion is a poignant story of a comfortable status quo coming up against practical reality. The tug of nostalgia for a passing time must be weighed against the practical need for housing for

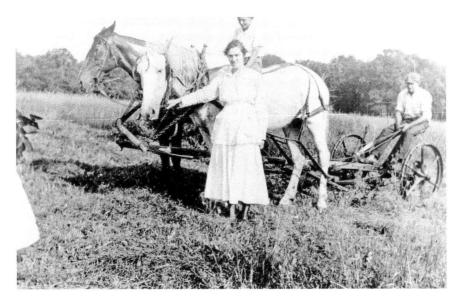

Neumanns plowing rig, circa 1930s. *Courtesy of Mike Martino.*

Interstate 91. *Courtesy of the Rocky Hill Historical Society.*

a growing population. The Rocky Hill Historical Society has launched a project to collect oral histories from people who remember the Rocky Hill of the past. One of the themes being pursued is the recollections of farm people lamenting the loss of their lifestyle, as well as those of real estate developers and the descendants of real estate developers celebrating the march of progress. The goal isn't to take sides but to capture what has been a watershed time in Rocky Hill's history.

EVOLUTION OF THE POSTAL SERVICE IN ROCKY HILL

In the early days of colonization, mail delivery worked on the honor system. Mail was passed from hand to hand, often through ordinary people, including Natives, with the expectation that the mail would get to its named recipient. This system worked surprisingly well for personal mail within the colonies.

The first formal postal stops were designated to handle mail coming from overseas, since it often addressed political and commercial issues. Mail arrived in Rocky Hill via post riders and on the Connecticut River. Typically, taverns, coffee houses and other public places served as collection and distribution points for mail. The mail service was a sideline for these places.

In 1673, a mail delivery route was established between New York City and Boston. This became the original Boston Post Road. The Upper Post Road branched off from this one, and a lower branch of the upper road ran from North Haven to Wethersfield and passed through Rocky Hill. During this period, mail delivery was typically carried on horseback three times a week, and mail was delivered in both directions.

As early as 1683, primitive postal services were established, and private messengers notified recipients that they had mail. These local—somewhat ad hoc—systems proved unsatisfactory, and in 1707, the British government took control of the postal service.

In 1737, Benjamin Franklin was appointed royal postmaster of Philadelphia. He became co-postmaster of the colonies in 1753. The British

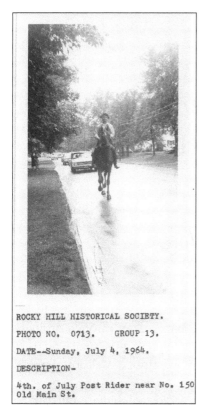

ROCKY HILL HISTORICAL SOCIETY.

PHOTO NO. 0713. GROUP 13.

DATE--Sunday, July 4, 1964.

DESCRIPTION-

4th. of July Post Rider near No. 150 Old Main St.

Post Rider reenactor. *Courtesy of the Rocky Hill Historical Society.*

Crown dismissed him as postmaster in 1774 because of his obvious sympathy for revolutionary interests.

Revolutionary sentiments caused fears that Crown officials would begin opening and inspecting colonial mail. William Goddard set up the Constitutional Post for intercolonial mail as an alternative to the British Crown's post in 1774. Franklin became the colonial postmaster general in 1775. His service was so successful that the British Crown's mail service had to shut down by Christmas of that year due to low service volume. Franklin only served as postmaster general for about a year. A few months after independence was declared in July 1776, Franklin changed roles from postmaster to ambassador. He was dispatched to France to perform as the ambassador to the court of King Louis XVI.

In 1781, the Articles of Confederation were ratified. Article IX formalized the postal system and made it a federal responsibility. In 1788, the power to establish post offices and postal routes was included in the United States Constitution. In 1792, postal officials were forbidden from opening or censoring mail, except in times of war. The postal system that Franklin helped build continued to flourish and became a critical part of the new democracy.

The first post office in Rocky Hill was established in 1802, when the Saybrook Turnpike opened. The office was probably located in the home of the first postmaster, who the USPS (U.S. Postal Service) identifies as Isaiah or Josiah Butler. There are no records of an Isaiah Butler in any of the town's records. Josiah is a much better candidate. Mail was delivered to the Rocky Hill post office three times a week—first on horseback and later via stagecoach. In 1812, the Valley Hotel at the southwest corner of Grimes Road and Main Street served as the post office. Over the years, several people served as postmaster, using various locations for post offices.

Often, the private homes of postmasters were used, but sometimes, the post offices were located in stores, taverns and rental spaces. There was no official delivery system, although some private services filled this role. It was up to the recipient to pick up their mail. The post office periodically published lists of mail that hadn't been picked up in local newspapers. If a town didn't have a newspaper, the list was posted in a public place. After three months, unclaimed mail was sent to the dead letter file in Washington, D.C.

The Civil War resulted in thousands of soldiers who had seldom traveled far from home being separated from their homes and loved ones, often by thousands of miles. Communications with home became a serious morale issue. The Act of March 3, 1863, resulted in dramatic changes to the postal system. Rates, which had been based on the number of pages and distance traveled, were changed to be based on the weight of the item being shipped. This was combined with newly defined classes of mail. First-class mail was the most expensive and received priority in terms of speed of delivery. Second- and third-class mail was lower priority, so a letter that weighed very little and contained family news might go to first class, while a box of cookies or a warm scarf that weighed more might go second or third class.

Stamps became an issue during the war because soldiers in the field had a hard time keeping them dry and usable. Soldiers often didn't have access to postage at all. The postage that was due was authorized so that postage could be paid by the recipient. A serious problem was stealing money sent via mail. Postal money orders with a designated payee were authorized in 1863 to make it harder to steal money in the mail.

An innovation that vastly improved mail delivery while creating a decades-long controversy was the free delivery of mail to street addresses in population centers. Mailboxes appeared at houses in cities, but there was no official delivery system in rural areas like Rocky Hill. In effect, rural people's taxes supported a system that provided them with few benefits.

Today, we think of Rocky Hill as a residential community, with large expanses of tract housing and commercial sites. We struggle to preserve what is left of our farming heritage. This was not true before the arrival of Interstate 91. Rocky Hill was a rural farming community with the mail delivery issues of most rural communities. Rural Free Delivery (RFD) began in the United States in the late nineteenth century in response to the rural population's dissatisfaction with the quality of rural mail service. Universal implementation was slow. RFD was not generally adopted until 1902. The RFD used a network of rural routes traveled by carriers to deliver mail and pick it up from roadside mailboxes, so mail still didn't show up on rural

doorsteps. It was delivered to a neighborhood where residents could easily access it. RFD was the way in which mail was delivered in Rocky Hill until 1957.

Interstate 91 came to Rocky Hill in 1965, making the town accessible to commuters. In 1960, the population of Rocky Hill was 7,404. By 1970, the population had grown to 11,103, and it has continued to boom ever since. Real estate developers and other Rocky Hill people realized early that the interstate would result in dramatic population growth and began planning for it. In 1957, the RFD system began to be replaced with door-to-door mail delivery. Old street names were replaced with new names that made more sense to new people. House numbers that worked when houses were sparse and there was plenty of empty space needed to be renumbered to accommodate lots designated for new construction. A cross-reference of pre-1960 house numbers and current numbers, which are available at the town clerk's office and at the Rocky Hill Historical Society, demonstrates the extent of new development.

After years of changing locations, the U.S. Post Office settled in its current home at 32 Church Street in 1975. Its last location before it found its permanent home on Church Street was a rented space in the blighted Grant's Plaza, where the abandoned Ames Plaza is now located.

The next chapter will cover postal people in Rocky Hill.

Postal Heroes and Villains

Postmasters have served in Rocky Hill since 1802. Some have served admirably—others, less so. As so often happens when you dig into the details of Rocky Hill's history, human-scale people and stories are uncovered that are worthy of William Saroyan.

The first postmaster in Rocky Hill, appointed on August 6, 1802, is usually identified as either Isaiah or Josiah Butler. There is no record of an Isaiah Butler in Rocky Hill on www.ancestry.com during this period. A more likely candidate is Josiah Butler, who is buried in Center Cemetery (born in 1768 and died in 1845).

Archibald Robbins was the seventh Rocky Hill postmaster. He may be better known for writing a book about his voyage on the brig *Commerce* and being enslaved in Morocco. He owned a store in Rocky Hill and was the postmaster here from 1832 to 1838. He was also a storeowner and postmaster in Solon, Ohio.

Henry Whitmore served two terms as postmaster, from 1841 to 1845 and 1849 to 1853. The post office was then located at 20 Riverview Road, which was also rumored to have been a stop on the Underground Railroad.

As far back as 1772, Benjamin Franklin saw the need for oversight of the postal service and established the role of postal surveyor. The name of this role was changed to special agent in 1830. In 1880, the postal service decided that the title of special agent was overused (Pinkerton Agents, et cetera), and the name was changed to postal inspector.

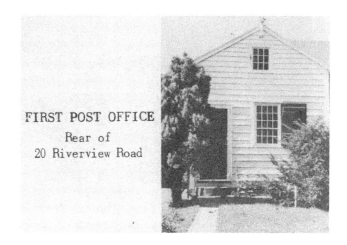

FIRST POST OFFICE
Rear of
20 Riverview Road

First Rocky Hill Post Office. *Courtesy of the Rocky Hill Historical Society.*

The first official to uncover shady exploits in Rocky Hill was Special Agent Holbrook in 1861. Henry Webb had been appointed postmaster in 1847. He was removed and replaced by Henry Whitmore in 1849. Webb was reappointed in 1853. In 1861, Special Agent Holbrook responded to several complaints from the town's residents. Among the complaints were: missing letters, letters that arrived without their valuable contents, mail that had been prepaid being sent with postage due or not sent at all (often the records of prepayment had disappeared). An article in the February 1, 1861 edition of the *Hartford Courant* says that Postmaster Webb, faced with this scrutiny, "Suddenly disappeared for parts unknown." A.G. Parker took over as postmaster and apparently reestablished the damaged reputation of the office of postmaster.

Parker reestablished the credibility of the postmaster, and things ran smoothly until 1916. Although there was a strange interlude when Harry A. Frye, the RFD letter carrier, reported that he was going on a short vacation and was never heard from again. Other than the disruption caused by an AWOL letter carrier, things continued to run smoothly.

Fifty-five years after the Henry Webb scandal, there were, again, shady acts at the post office. In 1916, Edward A. Peck was arrested by Deputy Marshal Timothy E. Hawley after serving five months for embezzling $68 (about $1,600 in 2021) of post office money. His behavior seems to have been caused by a serious drinking problem. It is unclear if his missteps were the results of criminal activity or alcohol-induced confusion. He was institutionalized for treatment rather than indicted.

Eight years later, in 1924, another postmaster ran afoul of the law. Postmaster Arthur W. Dickinson was arrested for embezzlement by Deputy

Marshal Albert B. Marsh after Postal Inspector Edward A. Courter performed an audit and found $198 missing. This seems like petty cash, but it is approximately $3,000 when adjusted for inflation. The consequences couldn't have been too great. Subsequent records show that Arthur W. Dickinson was employed as a truck driver for the state highway department and as second captain on the Rocky Hill–Glastonbury Ferry.

Charles Yeager is remembered as a pillar of the community for the roles he played and the contributions he made to Rocky Hill. He was station agent at the Rocky Hill Station of the New York, New Haven and Hartford Railroad when the station was the nerve center of commerce and commuting for Rocky Hill and South Glastonbury. He also served as a constable, a game warden, the secretary of the board of education and an agent of the Connecticut Humane Society.

From 1934 to 1955, the office of postmaster was in the capable hands of Yeager. The post office was beginning to enter the modern era in 1955, when he retired and was replaced by Joseph P. Levasseur, who oversaw the establishment of the modern post office.

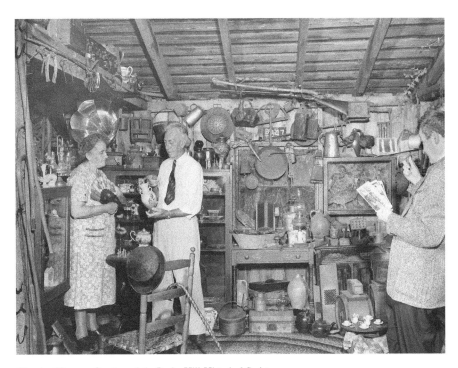

Charles Yeager. *Courtesy of the Rocky Hill Historical Society.*

One of Yeager's important contributions and mysteries was the Stepney Museum. He collected and organized an impressive collection of historical artifacts that he kept in a barn behind his home at 1 Pratt Street from 1951 to 1959. He died in 1959. The Friends of Cora J. Belden Library spun off the Rocky Hill Historical Society as a separate organization in 1960. Given the timing, one has to wonder, "Did Mr. Yeager's museum evolve into the Rocky Hill Historical Society?" One also has to wonder, "What happened to all those historical artifacts?"

Starting in 1919, when Ray Evans took over as RFD deliveryman, the mail was delivered to its drop points correctly. When Charles Yeager took over as postmaster, the two men formed an effective team that managed the mail until 1957. In 1919, the RFD route was twenty-seven and a half miles long, with 240 stops, or 30 stops per hour. Early in his career, Ray most often hitched a horse named Old Pete up to a mail wagon to make the route, as primitive automobiles couldn't always be relied upon, especially when the snow got too deep. Old Pete knew the route and could be relied on to stop at all the mail drops. Automobiles eventually won out, and Ray reported using up to eight cars to deliver the mail between 1930 and 1942. All that stopping and starting meant he went through a lot of transmissions, clutches, tires, et cetera. Ray got to know the people on his route and often made deliveries of things that had nothing to do with the mail, such as chickens and flowers. Things were often informal then. People would leave coins for postage, rather than stamps. Ray carried a hammer and chisel to loosen coins that had been frozen to the bottom of mailboxes.

Ray was a veteran of World War I and an active member of the American Legion. Among his contributions was the development of a list of all veterans buried in Center Cemetery as of 1961.

Postal routes, mailmen and door-to-door delivery were all instituted in Rocky Hill in 1957 in anticipation of the completion of Interstate 91 and a population boom. Ray, whose expertize was RFD delivery, retired in 1961.

The U.S. Postal Service provides a complete list of Rocky Hill postmasters starting in 1802. This is available at the Rocky Hill Historical Society or at www.webpmt.usps.gov.

History of the Rocky Hill Library

Until 1794, Rocky Hill people must have used the Union Library Society in Wethersfield when they needed a library, although this involved travel and inconvenience. In 1794, the Social Library of Stepney Parish was formed under the sponsorship of the Congregational church's pastor Reverend Calvin Chapin in his home, which still exists at the northeast corner of Chain Avenue and Elm Street.

This library was a subscription library with sixty-eight original subscribers, who had access to the library's eighty-seven original books, with subsequent purchases planned. Reverend Chapin was the social library's first librarian, and the books were kept in his home. The library was subsequently relocated to a store on the ferry landing.

The Free Library of Stepney Parish was established in 1795, one month after the social library of Stepney Parish. It was formed because many residents of Stepney Parish considered the social library elitist and exclusive due to the fact that membership in the social library was contingent on acceptance by a membership committee. The rules of the free library stipulated that the only qualification for membership was payment of dues (without any other screening process).

Having two libraries in a small place like Stepney Parish created competition and contention. By the 1820s, more open-minded people were making the decisions, and cooler heads prevailed. The two libraries agreed to combine and retain the name of the social library. The two libraries were combined in 1829. When Reverend Chapin retired, the new pastor of the

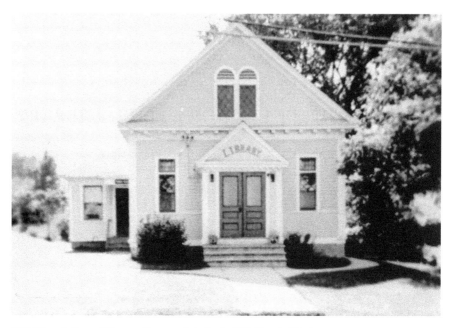

Old Church Street Library. *Courtesy of the Rocky Hill Historical Society.*

Congregational church, Reverend Lebbeus Rockwood, became librarian. He merged the social library with another organization he had formed, the Rocky Hill Lyceum, and established the Social Library Association of Rocky Hill. The library was run from his home at 42 Riverview Road. By 1876, it was generally agreed that the library should have its own home, rather than be operated out of a private home.

The Rocky Hill Library was formed and merged with the social library in 1877. In 1886, the library moved to the second floor of Academy Hall, where it remained until 1896. The library was then moved to the former Valley Hotel, also called the Bulkeley House, on the south corner of Grimes Road and Main Street. This building has served as a hotel, a post office and the library.

The Rocky Hill Library Association made an effort to establish a permanent home for the library in 1899 with the purchase of land on Church Street. A library building was dedicated in December that year. This building was on the west side of Church Street, where the O.R.&L. Realty parking lot is today. In 1925, the operation of the library was turned over to the town as a free library—that is, without the fees that had been required in the past. At a town meeting in 1950, the library was named the Cora J. Belden Library, after a woman who had been active in support of

the library and who, along with her husband, Elwood Belden, had been active in town affairs. In 1967, the library building that currently exists was dedicated on Church Street. The old library building served as the home of the Rocky Hill Theater Group for a while. It was dismantled in 1982 and moved to 121 Miller Road in Canterbury, Connecticut, where it is being used as a private home.

GRANDMA GRISWOLD
AND SUNNY CREST FARM

One of our historically minded friend's, Joe Kochanek's, quotes applies to much of Rocky Hill's history: "People die two deaths—first, when they die and, second, when they are forgotten." There are many people who are fading into the mists of antiquity who deserve to be kept alive. Margaret "Grandma" Griswold is one of those people.

Grandma Griswold was born on Pratt Street (probably 47 Pratt Street, which burned down in the early 2000s), on February 27, 1868. Her father was Horace Williams, a Civil War veteran who moved to Rocky Hill from Farmington, Connecticut.

The path to an education in the nineteenth century was not what it is today. High school was considered higher education, and college was for the privileged few. Grandma Griswold attended nine grades of school in Rocky Hill and then decided to attend New Britain Normal School (modern Central Connecticut State University) in lieu of attending Hartford Public High School. New Britain Normal School was a teachers' college at the time, and she aspired to be a schoolteacher. Getting from Rocky Hill to New Britain Normal School involved a daily trek. It seems daunting to us, but people seem to have been tougher back then. She walked from her home to the railroad depot, took the train to Hartford and then transferred to the train from Hartford to New Britain. She did this regularly for two and a half years.

She graduated in 1887 at the age of twenty-one and taught a term in East Windsor before becoming the teacher at South School, a one-room schoolhouse. The building still exists today as the cable TV station at the

southeast corner of Main and Forest Streets. She taught grades one through nine simultaneously.

Grandma Griswold was tested in her first year as a teacher by the infamous Blizzard of 1888, one of the most severe recorded blizzards in American history. The storm paralyzed the East Coast, from the Chesapeake Bay to the Atlantic provinces of Canada. Snow fell between ten and fifty-eight inches deep. Sustained winds of more than forty-five miles per hour produced snowdrifts in excess of fifty feet. The blizzard started on Sunday night, and children arrived for school early on Monday morning (snow days were rare back then). There were no telephones or means of mass communication. By the time it became clear that this was one of the worst blizzards in recorded history, the snow was so deep that most of the parents couldn't reach the school on foot or horseback, and the children had to be retrieved in ox carts. Grandma responded to the emergency and saw to the well-being of the children until their parents could rescue them.

Grandma married William S. Griswold in the spring of 1888. She later retired as a teacher, partly due to ill health and partly to focus on raising a family. William established the W.F. Griswold Dairy in 1896. Early products on Sunny Crest Farm were tobacco, fruit and vegetables. It eventually evolved into a dairy farm. The farm grew through land acquisitions until its boundaries extended to both sides of Parsonage Street, Orchard Street, Chapin Avenue, and Elm Street. By 1934, William S. Griswold was the wealthiest person on the Rocky Hill grand list. The home at 189 Parsonage Street was the Griswold Farmhouse from the 1890s. The Griswolds sold it in 1991.

William died in 1936, and the Sunny Crest Farm Trust was set up for the benefit of his surviving heirs. Grandma Griswold became its controlling matriarch. Well into her nineties, she was aware of all the issues related to the Sunny Crest Farm Trust and was still signing all the checks for the trust.

Operating a farm of this size was not without its setbacks. Two fires were particularly destructive. In 1930, an overheated bearing in a hay chopper caused a fire that destroyed a two-hundred-foot-long dairy barn and three silos. Fortunately, the cattle were out to pasture, and none were lost. In December 1944, Sunny Crest was not so lucky. A fire leveled three barns and three silos and killed eighty-five cows. Three hundred tons of hay and seven hundred tons of silage were destroyed.

The arrival of I-91 cut out a large swath of Sunny Crest Farm and divided the farm into sections. The highway also allowed a large population to commute to Rocky Hill and created immense pressure to

Sunny Crest Farm Barn on Orchard Street, circa 1944. *Courtesy of the Rocky Hill Historical Society.*

divide Rocky Hill farms into tract housing. Logistics became a problem. As land was taken for housing, hay had to be grown in the meadows and trucked to the cow barns on the farm. Sunny Crest Farm ceased operations in 1973 and turned its customer base over to Mohawk Farms of Newington.

Grandma made many contributions to the town. She was a member of the Grange, a powerful lodge that represented farmers, for over fifty years. She was member of the board of education, which was called the school board for much of its history; a director of the old Cora J. Belden Library; a secretary of the Rocky Hill Cemetery Association; a treasurer of the Ladies' Benevolent Society; and an active member of the Rocky Hill Congregational Church.

Remnants of Sunny Crest Farm can still be seen along Parsonage Street. Although much of the farmland was given over to tract housing, the land for Sunny Crest Park was purchased by the town in 1969. Rocky Hill High School sits on land that was once a Sunny Crest Farm apple orchard. Chapin Avenue once ran from Elm Street to Mountain View Drive, and north of this was land that was part of Sunny Crest Farm. Griswold Road forms the western boundary of the high school. Sunny Crest Drive was once part of the farm, as was Apple Grove Road, Winesap Circle and Macintosh Circle.

Grandma Griswold's children left their marks in Rocky Hill as well. William F. and Grandma Griswold had ten children, all born in Rocky Hill. The Griswolds and their children were all active in the Congregational church.

Frank Griswold was born in 1889. He died in May 1976 in Cromwell, Connecticut. Frank was a Rocky Hill selectman from 1936 to 1937. He then moved to Cromwell. He was a thirty-year member of the Rocky Hill Grange.

Albert Deming Griswold was born on September 15, 1890. He died on June 2, 1974, in Rocky Hill, Connecticut. He was the chairman of the Rocky Hill Board of Education. Albert D. Griswold Junior High School was named for him. He was a dairy farmer, delivered milk in Hartford and was a Sunny Crest trust partner.

Hayden Griswold was born on July 4, 1892. He died on September 14, 1983, in Manchester, Connecticut. He was a World War I veteran, a founder of the Rocky Hill and Manchester Planning Boards, a founder of Griswold and Fuss Engineering Firm in Manchester, a member of the Manchester School Building Commission and a trustee of the Heritage Savings and Loan Association.

Helen A. Griswold was born in June 1894. She died on October 2, 1956, in Hartford. She was a Sunny Crest trust partner and treasurer of the Rocky Hill Grange.

Mary Griswold was born on May 28, 1896. She died on April 3, 1992, in Rocky Hill, Hartford County, Connecticut. She was employed by the Allen, Russell and Allen Insurance agency for forty-two years, was active in the Ladies' Benevolent Society and was a fifty-year member of the Grange. She was active in the Stepney Seniors and the Rocky Hill Historical Society.

Arthur Stewart Griswold was born on September 22, 1898. He died on June 12, 1972, in Detroit, Wayne County, Michigan. He was a vice-president at Detroit Edison, a World War II consultant in the development of electricity in developing countries and general manager of the Detroit Nuclear Power Plant.

Leonard Griswold was born around 1901. He died in February 1968 in Rocky Hill, Hartford County, Connecticut. He served on the town planning commission from 1930 to 1959, in the state legislature from 1935 to 1936 and as fire chief from 1941 to 1945. He was the past master of the Grange, president of the Rocky Hill Cemetery Association and a Sunny Crest trust partner.

William F. Griswold Jr. was born around 1903. He died on September 13, 2001, in Saint Petersburg, Pinellas County, Florida. He was a dairy farmer and a Sunny Crest trust partner. He delivered milk.

Margaret Griswold was born in 1905. She died in 1993. She was married to Edwin W. Cooper and lived in Eastford, Connecticut, where she was town clerk for twenty-six years.

Catherine Griswold was born in 1910. She died in 2002. She married Joseph Adamiak and moved to Yonkers, New York.

Grandma's children ranged in age from fifty-nine to eighty at the time of their deaths. In 1970, she had twenty grandchildren, forty-four great-grandchildren and three great-great-grandchildren.

She was living at West Hill Convalescent Home when she died at the age of 102 on April 12, 1970.

ROCKY HILL'S HAIRLESS BOVINES

Not all of Rocky Hill's human-interest stories are about humans. Hairyette the cow became a local celebrity in Rocky Hill in the early 1950s. A cow on Hayes Farm in West Rocky Hill, Hairyette was the mother of a bull named Pinky. Pinky was born in 1952 with no hair and wasn't expected to live. He almost died from a bout of pneumonia, but he survived and grew to 1,800 pounds, reigning over a harem of ninety cows (lucky Pinky). His career as a bull became a triumphant success story. As of 1954, Pinky had sired seven or eight healthy hair-covered calves.

Pinky became a local celebrity and was featured in several local magazine articles. One of the problems of being a bald cow in Connecticut is that it gets cold in the winter, and sunburn is a threat in the summer. Pinky's fame brought him to the attention of Phillip I. Lerner Furriers in Hartford, which fashioned a $500 (almost $5,000 in 2021) mouton fur coat for him. Mouton is sheepskin cut and dyed to resemble beaver fur or sealskin. It wasn't mink, but it wasn't bad—so, we're talking one well-dressed bull. The girth of the coat was fifty-four inches, and the length from horns to rump was seventy-two inches. Clearly, such a fine garment wasn't for everyday wear. It was brought out and put on when it was very cold or very hot. We know today that fur is murderous, but this information wasn't available to Pinky and his sister back then.

The other cows didn't seem to want to fully accept the cows in fur coats. This may have been due to jealousy, but it was probably more of an unwillingness to accept diversity. Cows weren't very woke in 1952. There are photographs of other cows headbutting or shunning Pinky.

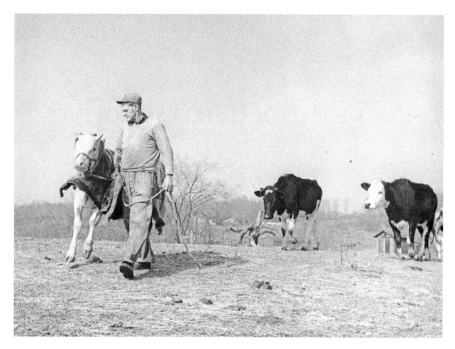

Hairless cow. *Courtesy of the Rocky Hill Historical Society.*

In 1954, Hairyette gave birth to another bald cow who seemed to have been given the name Hairless. This seems cruel—like calling a bald person Curly or a tall person Shorty—and probably warped the poor girl's personality. The birth of a second bald cow was astonishing to veterinarians, who claimed that only 1 in every 100 million calves is born hairless.

So, why was there so much attention given to a story about cows in the 1950s? Cows were a big part of Rocky Hill's economy back then. Most of the land west of the Silas Deane Highway was farmland. Most of the farms were dairy farms. If you drove down Elm Street in the 1950s, you would see a sparse sprinkling of houses and large tracts of land with cows grazing on them. A story of nonconforming cows would have been an interesting and amusing story to the people of the 1950s who knew their cows.

The big dairy farms are gone now, but if you want to get a feel for what Rocky Hill was like back then, take a ride out New Britain Avenue to Hayes Road and pull in at Hayes Farm. Look across the street and wave hello to the bovine girls wading or grazing there. Give the free-range chickens and goats a nod and then go into the farm store and buy some eggs, meat or other local goods. This is a good way to support our local farmers.

A Drinking History of Rocky Hill

For much of Rocky Hill's history, the question of "to drink or not to drink" has been a hot topic. A December 3, 1933 article was titled "Rocky Hill, with Liquor Back." The article described the alcohol consumption history of Rocky Hill, including its decision to "go dry," and it emphasized the fact that, even after the Eighteenth Amendment to the Constitution had been repealed, Rocky Hill still didn't issue liquor licenses. According to this article, from 1780 to 1820, an average of twenty ships sailed to and from Rocky Hill per year. A significant part of their cargos was rum, wine and brandy and molasses and sugar, which was used to make alcoholic beverages.

Early in the town's history, drinking was a way of life. Beer was the beverage of choice on the *Mayflower* because the water was so tainted and suspect. The pilgrims landed on Cape Cod to replenish their supply of beer. In the nineteenth century, general stores commonly kept a barrel of whiskey on hand, and a farmer might take a half-pint dipper of whiskey to get him through an afternoon of plowing.

Until 1818, the Congregational church was the official church of Connecticut, and it served as the arbiter of good behavior. The importation of liquor was an integral part of the Rocky Hill economy. It was an economy in which communicants of the Congregational church shared. Although alcohol, in moderation, was served to medicate and ease pain early on, people were aware that overindulgence could lead to bad results. The bad results gradually created a conflict of interest for churchgoers.

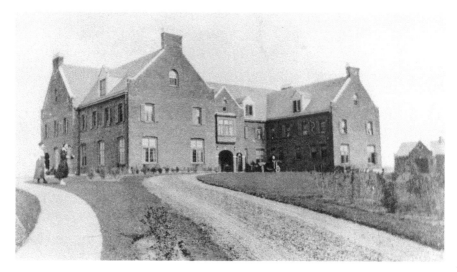

Club Hollywood. *Courtesy of the Rocky Hill Historical Society.*

It should come as no surprise that, in Rocky Hill's early history, tension existed between the puritanical Congregational church and the more worldly maritime people. It's hard to imagine today that the riverfront, from Ferry Park to Dividend Brook, was once the home of shipyards, shops, hotels, taverns and distilleries. The goings-on of the lusty young men from around the world who inhabited the riverfront are best left to the imagination.

Calvin Chapin became the pastor of the Congregational church in 1794. He became an influential presence statewide for the Congregational church and was an aggressive advocate for temperance. By the time he died in 1851, the Congregational church had become a center for the advocacy of temperance. This was in contrast with the town in general. Rocky Hill had become the home of saloons, taverns, et cetera, such as Shipman's Tavern, the DeRyer Inn and the Valley Inn.

For most of Rocky Hill's history, until 1937, when Rocky Hill's first full-time police chief was appointed, law enforcement was the purview of the state policing agencies supported by town constables. Constabulary duties were a part-time activity in addition to the constables' other means of employment. Constables handled traffic issues, burglaries and other nonfatal events and had the power to arrest. Constables supported the state police in interdicting illegal activities, such as gambling, prostitution and illegal liquor sales. Police enforcement was sparse, and Rocky Hill was known as a "wide-open" town. Owen R. Havens said that Rocky Hill "had an A-1 bad name."

This didn't sit well with law-abiding people, and the battle was on between the rowdier "wets" and the "dry" forces of temperance.

It's easy to take sides with the "wets" now that we know that Prohibition brought with it contempt for the law and the rise of organized crime. It's harder to remember the time when blackout drinking was common, accompanied by family violence and the incapacitation of wage earners. Before Prohibition, it was not uncommon to find drunken men passed out in the street. Farmhands might show up for work drunk. The goal of the "drys" was to end this, and they were militant about it.

There was a powerful movement in town to cease the issuing of liquor licenses. In 1895, an ordinance was passed that said no liquor licenses were to be issued in Rocky Hill. Congregational church pastor Clay Chunn was dismissed from his position in 1897 due to his lack of support for this movement and because he had filled a canteen with sweet cider and had taken a sip.

To some extent, the issue created tensions between puritanical Anglos and recently arrived immigrants. There was a growing German and Jewish population that brewed and drank beer. Italians considered wine a food. The Irish had a drinking tradition. Drinking didn't cease—it went underground. Unlicensed drinking places and bootlegging thrived in Rocky Hill. In 1898, Judge Louis Button organized the Law and Order League. Its mission was to drive illegal liquor out of Rocky Hill. He closed six illegal liquor outlets, but he almost certainly didn't find them all.

The Eighteenth Amendment was passed on January 16, 1919, declaring that the production, transport and sale of intoxicating liquors was illegal, although it did not outlaw the actual possession or consumption of alcohol. This amendment was repealed on December 5, 1933, but the Rocky Hill town ordinance remained in force for two more years, in spite of increasing pressure to repeal the "no liquor license" ordinance.

During the Great Depression, in 1932, disgruntled veterans marched on Washington, D.C., to demand an early payment of their veterans' bonuses. When this failed, thirty-five of them returned home to Connecticut. There was no room for them at the Veterans' Home at Noroton Heights, so they were put up at a farm in Rocky Hill that supplied produce and dairy products to the Noroton Heights Veterans' Home. The population of veterans on this farm increased, and this facility evolved into the Rocky Hill Veterans' Home. This group of ex-soldiers developed into a large drinking population. Pressure increased for liquor licensing.

The Club Hollywood, which was located on the current site of Maple View Manor Convalescent Home, was instrumental in the repeal of the

"no liquor license" ordinance. The club was opened in 1934 by the Trotta-Pestritto Dance Band, and it was designed to be an upscale dance and supper club. Liquor licenses were still illegal in 1934, but it seems likely that there was more than one hip flask on site and that the liquid in the teacups might not always have been tea. A nightclub with no liquor license operates at a disadvantage. The club closed in 1934 and was auctioned off. This must have put a dent in the town's grand list during the early years of the Great Depression. It reopened in October 1935, offering dining, accommodations for large parties, dancing to well-known dance bands and professional dancers, magic and other acts. In December 1935, the club was issued a liquor license. The reopened club featured a large horseshoe bar, nationally known entertainers and two shows nightly.

The town's liquor laws have changed and evolved over the years. Old-timers may remember when liquor stores had to close at 9:00 p.m. (this was changed to 8:00 p.m. to discourage closing-time robberies), liquor stores were closed on Sundays and bars closed at 9:00 p.m. on Sundays. This might have discouraged drinking to some extent, but more often, it involved planning ahead to ensure adequate liquor supplies and many high-speed trips to Springfield, where the bars were open until midnight on Sundays. It also encouraged a diminished bootlegging industry.

Rocky Hill has grown. It is no longer a country village with a handful of constables and a resident state trooper to enforce the law. It has all of the amenities and features of a large city, including a professional police force. Gone are the days when people could go to a small, lightly policed place like bygone Rocky Hill and act like sailors on shore leave. Most people who drink are responsible, and those who aren't responsible often show up in the police column of the *Rare Reminder*, a regional paper.

About the Author

B
ob Herron has been the Rocky Hill town historian since 2017. He has served as a researcher for the Connecticut Historical Society, the Godfrey Memorial Library and the Rocky Hill Historical Society. His writing credentials include a book on Rocky Hill in World War I, an article on the history of the Rocky Hill Veteran's Home that appeared in the spring 2016 issue of *Connecticut Explored Magazine*, a profile of State Senator Richard Tulisano, *Images of America: Rocky Hill* (Arcadia Publishing, 2019) and an evolving history and timeline of Rocky Hill that can be viewed at www.rockyhillct.gov.

Bob grew up in Hartford. He served four years in the United States Air Force as an airfield firefighter and graduated from Central Connecticut State University in 1972. He has enjoyed a successful career in computer systems methodologies and data architecture. In addition to his career responsibilities, Bob taught courses in systems analysis and design at the Greater Hartford Community College and delivered guest lectures at the University of Michigan. He has published extensively and has presented papers at several professional computer forums, including GUIDE, COMDEX, the Knowledgeware User Group, Frequent Data Architecture Management Association meetings and the Structured Development Forum. He retired in 2003.